ANSELM KIEFER

*t*he Seven Heavenly Palaces 1973–2001

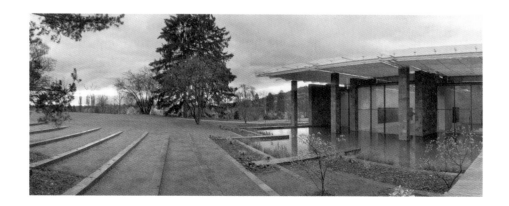

ANSELM KIEFER

the Seven Heavenly Palaces 1973–2001

With an essay by Christoph Ransmayr

and contributions by

Markus Brüderlin

Mark Rosenthal

Katharina Schmidt

FONDATION **BEYELER**

Hatje Cantz Publishers

Lilith, 1997
Emulsion, shellac, acrylic, lead, hair and ash on canvas, 330 x 560 cm
Private collection

Acknowledgements

Anselm Kiefer showed a deep commitment to the exhibition project "*t*he Seven Heavenly Palaces" from the outset. I wish to express my heartfelt thanks to him for this extraordinary collaboration. We also wish to thank the author Christoph Ransmayr for having embarked on the adventure of a literary expedition into Kiefer's extensive, complex terrain and for his sympathetic essay, which transforms this publication into something beyond a normal catalogue. Our thanks likewise go to Thomas Flechtner for the photographs he brought back from his journey to the south.

We should also like to express our gratitude to everyone who offered us advice and assistance with this adventure of the senses and the intellect: Heiner Bastian, Peter Blum, Gottfried Boehm, Bazon Brock, Rudi H. Fuchs, Hans-Joachim Müller, Mark Rosenthal and Katharina Schmidt as well as many others. I am particularly indebted to Ernst Beyeler for his suggestions and support, without which this exhibition would not have been possible.

Among the many people who helped us to locate and obtain the works on show were Peter Weiermair, Galleria d'Arte Moderna di Bologna, Lorcan O'Neill of the Anthony d'Offay Gallery in London, Emanuela Campoli of the Gagosian Gallery, New York, and the Collection Lambert, Musée d'art contemporain, Avignon. Special thanks go to Walter Smerling of the Stiftung für Kunst und Kultur e.V. for his remarkable commitment. We are also very grateful to Sylvie Pagès, Anselm Kiefer's assistant, for the patience with which she responded to our requests for important pieces of information.

Our thanks go to the staff of the Fondation Beyeler for their untiring dedication: the research work and liaison with lenders were most competently begun by Tanja Narr and were then continued by Viola Weigel (exhibition assistant), who provided the curator with invaluable support in many areas. The logistical tasks associated with moving the works, some of which are immensely large and fragile, presented particularly great challenges, which our registrar Nicole Rüegsegger overcame with great skill. The overall coordination and organization of the exhibition's installation were handled by Verena Formanek, together with her indefatigable colleagues Ben Ludwig (head of the technical installation team), Ahmed Habbech and Dieter von Arx as well as Markus Gross and Friederike Steckling (conservators). Alex C. Pfenniger took care of all the insurance aspects. Fausto De Lorenzo was in charge of commercial aspects and operational requirements in the museum while Beat Privat provided the necessary financial, technical and manpower resources. Bettina Mette (press relations), Marina Targa (communication) and Jeannette Stöcklin (organization of events) did most of the public relations work for the project. A major challenge awaits the members of our Guide Line team who, under the leadership of Philippe Büttner and Michèle Klöckler, will explore the exhibition's theme in numerous guided tours with interested visitors.

A very significant component of this project is the catalogue, for the publication of which Delia Ciuha, as the editor, was mainly responsible, with the support of her colleagues Astrid Bextermöller and Viola Weigel. I should like to express my very special thanks to them. My sincere thanks also go to Linda Ludwig for the great care with which she checked my manuscripts and to David Britt, Isabel Feder, Ishbel Flett and John E. Woods for their sensitive translations. We also wish to thank the publisher Annette Kulenkampff, the chief editor Christine Traber and the production manager Christine Müller of Hatje Cantz Publishers for their exceptional commitment to a project for which the deadlines were very tight. Urs Albrecht merged the ideas expressed, the highly detailed information and the many illustrations into a visually appealing whole. Our heartfelt thanks go to Christoph Ransmayr, Katharina Schmidt and Mark Rosenthal for having provided the intellectual raw material as well as to Renate Graf for her marvellous photograph of the artist and the author in Kiefer's studio. We are also most grateful for the support we

have received from the *Basler Zeitung*, Crossair, KUL-
TUR Basel-Stadt, MANOR, the Riehen authorities,
Bank Sarasin & Co., UBS and *Die Weltwoche*.
Special thanks go to the following private lenders and
museums for their valuable loans:

Collection Sanders, Amsterdam
Staatliche Museen zu Berlin, Nationalgalerie,
Collection Marx
KunstMuseum Bonn, Collection Grothe and
Collection Sylvia and Ulrich Ströher
Anthony d'Offay Gallery, London
Eric Fischl, New York
Astrup Fearnley Collection, Museet for Moderne
Kunst, Oslo
Museum Boijmans Van Beuningen, Rotterdam
Staatsgalerie Stuttgart – Graphische Sammlung
Tate

as well as to those lenders who do not wish to be
mentioned.

Contents

Preface

Anselm Kiefer, who was born in Donaueschingen shortly before the end of the Second World War, is one of the most significant—and controversial—of contemporary German artists. His monumental painting *Deutschlands Geisteshelden* (*Germany's Spiritual Heroes*, 1973), which he showed in the German Pavilion at the 1980 Venice Biennale, met with divided opinions, among German art critics in particular. Those on one side viewed it as a homeward march into "the glorious past, with colours flying", or as "Teutonic mythomania"; for those who took the opposite view, this and similar works were "masterpieces of cultural archaeology"—which pinpointed, with enlightened ambivalence, the pathological split in the German psyche: great emotions on one side, petty philistinism on the other. German museum curators, including Klaus Gallwitz in Baden-Baden and in Frankfurt am Main, and Jürgen Harten, organizer of the legendary 1984 Düsseldorf exhibition (which was also shown in Jerusalem, to great acclaim), have attempted to set interpretation on the right lines. As early as 1981, the French, whose intellectuals have always had a *faible* for German culture—think of their attitude to Nietzsche and Heidegger—took a great interest in Kiefer's artistic treatment of myth and history in the exhibition "Art allemagne aujourd'hui". (It remains an open question whether Kiefer tries to understand history through painting or introduces historical facts in order to redefine the activity of making art.) A touring exhibition co-curated by Mark Rosenthal in 1987 established Anselm Kiefer's reputation in the USA. Switzerland, by contrast, has maintained a certain reserve. Kiefer has not had a one-man exhibition in this country since the one at the Kunsthalle Bern in 1978—aside, that is, from the presentation of his books at the Kunsthaus Zürich in 1991. This means that "*t*he Seven Heavenly Palaces" at the Fondation Beyeler (which itself owns two major works by Kiefer) is the first individual exhibition of Kiefer's painting in Switzerland for twenty-three years. It is also the first major Kiefer exhibition in the German-speaking world since the retrospective at the Neue Nationalgalerie in Berlin in 1991: a remarkable fact that underlines the significance of the event.

Since Anselm Kiefer's controversial Attic Paintings and Stone Halls, the range of his work has greatly expanded; indeed, it has branched out in different directions. Today, we have before us an artistic cosmos specifically designed to touch and to live through the cultural existence of Western man, caught as this is between myth, history and art. "I didn't want to be a Holocaust specialist," Kiefer told a recent interviewer. This was by way of explanation of his interest in archaic myths from Mesopotamia; in the poetry of Paul Celan and Ingeborg Bachmann; in historical men of action, such as Alexander the Great; in the cosmologies of the Rosicrucians; and in Jewish mysticism and *Hekhalot* literature, from which the phrase "Seven Heavenly Palaces" derives. It is therefore appropriate to reconsider the earlier phases of Kiefer's career in the context of his work as a whole; and this exhibition sets out to make a specific contribution to that reappraisal.

The show at the Fondation Beyeler is not, however, a retrospective. Beginning with Kiefer's first cohesive group of works, the controversial Attic Paintings of 1973, it concentrates on four selected cycles in order to afford a succinct thematic cross-section of Kiefer's varied and prolific output. In it, we see him not as a history painter but rather as an architect of worlds and cosmic spaces [Welt(en)-Räume] that we can enter and traverse here and now. In the exhibition, these spaces are arranged like an enfilade of rooms, each deeper and wider in scope than the last. The exhibition begins with the "Attic Paintings" of the early 1970s, on themes drawn from Germanic sagas and Christian epics. These wooden interiors are followed by the "Stone Halls" of the early 1980s, which provoked some lively controversy inspired by their (in part) literal references to the architecture of National Socialism. From there, the view widens to take in the archaic, desertic "Brick and Clay Architectures" of the 1990s, before soaring above the horizon with the "Star

Paintings" of the present day. These four stages mark a trajectory that leads from the intimate, introverted Attic Paintings to the endless expanses of the universe, so to speak from microcosm to macrocosm. In the end, we return to earth with the monumental Sunflower Paintings. The works are set out beneath the crystalline glass roof of Renzo Piano's museum building, which has been temporarily transformed into an additional "Heavenly Palace". The installation is conceptually linked to Kiefer's 35-hectare studio compound at Barjac, at the foot of the Cévennes, where since 1993 he has been working on the ramifications of a vast *Gesamtkunstwerk*: a total work of art, a synthesis of installations, subterranean chambers, sheds and glass buildings.

Anselm Kiefer's art relates to literature in complex ways, which is why it makes sense to us to present his creativity, and the fascinating Barjac site in particular, through the eyes and the pen of a writer. Christoph Ransmayr, the author of the novel *The Last World* and "an apocalyptic individual who praises life" (Marcel Reich-Ranicki), has visited the artist in the South of France and written a sympathetic essay for this catalogue. The photographer Thomas Flechtner has captured the constantly mutating underground and overground spaces of the "Heavenly Palaces". Here I would also like to thank Katharina Schmidt and Mark Rosenthal for their original contributions to this publication. The exhibition "*t*he Seven Heavenly Palaces" could never have become a reality without generous loans from private collectors and museums. Thanks are due to the team that shared the intensive work of preparation, and to all who have worked on the project with such dedication. I am grateful to Ernst Beyeler for his generous support, and for his help and counsel throughout. Very special thanks to Anselm Kiefer himself, who was so spontaneously responsive to the idea of an exhibition on my very first visit, and who has worked with extraordinary commitment to make the project a reality.

Germanic sagas, and Germany's efforts to come to terms with its own history; the Jewish and Christian mysticism of redemption; archaic, timeless architecture, and the Byzantine iconoclastic controversy: is Anselm Kiefer a painter of the past—or rather of things past? This question was in my mind when, on an overcast November day, back in the last century, I set out from Marseille towards the foothills of the Cévennes and the "Last World" of Barjac. After a number of encounters, and many conversations, followed by the period of intensive preparation for this project, I can say that few artists in recent years have given me so intense a feeling of presence and contemporaneity as Anselm Kiefer. Of course, his art has no part in the modish crossover culture of art, lifestyle and design; it holds aloof from the garish Pop aesthetic and makes no response to the politics of the day; although Kiefer's paintings of the March of Brandenburg were overtaken by political reality when the Berlin Wall fell in 1989. Thematically, his art tends towards breadth—while younger artists, as the Viennese journalist Wolfgang Kos once aptly put it, create pithy brand logos on a narrow foundation in order to shoot as high as possible. In terms of cultural archaeology, his art tends towards depth, delving into history [Geschichte] through a succession of strata [Ge-schichte].

All the same, Kiefer's conceptual art never loses itself in the lower depths of history and myth. Themes, literary allusions, material and pictorial ideas are playfully interwoven with a surface movement in such a way to generate a highly diverse and dynamic topography of spaces accessible to present experience. This combination of surface and depth, horizontal and vertical, network and history, has much in common with the structure created by today's communications media. May this project convey something of the spirit and the idea of this entirely contemporary, and yet timeless, emergent total work of art.

Markus Brüderlin
Chief Curator, Fondation Beyeler

Christoph Ransmayr

The Unborn

or Anselm Kiefer and the Tracts of the Heavens

Here… this here is wilderness. Each footstep grows softer in the moss, in the grass and black foliage. And this here, this is the road, the new dirt road cut through the underbrush this spring, its surface of broken loam, stones, and sand still so loose and fragmented that our footsteps crunch as if on breaking ice. You can even hear the dogs padding. *Castor! Pollux! This way!*

How dark it is. New moon. Above the olives, acacias, and mulberry trees, the chirping darkness of early summer. *Pollux!* Those black rows of palisades there, as if cut from paper with scissors, must be the lines of poplars on the far side of the ponds. And those lances and butcher knives up there, directly below the Big Dipper, that's the avenue lined with cypresses. Not a lighted window anywhere. No glow from a city. Just a few scattered, distant sparks from Barjac, the nearest village.

Even from close up we can barely recognize our host, Anselm Kiefer, who is leading us around his property in southern France by the dark of night. Sometimes we simply follow a voice, the sound of footsteps moving off, a narrow shadow. Only a few of us know the way, and hardly anyone has walked it by a new moon. Strollers in the darkness, we try to stay close to Kiefer or at least within earshot, as his guests at *La Ribaute*, the abandoned silk factory that over the past decade has become more a bastion and asylum for our host than a residence. *Pollux! Castor!*—We stumble along behind his rottweilers. We could have been spotted trailing after him on other occasions, too, as collectors and art supply dealers, as gallery owners or

commentators and interpreters of his art. We are a master's entourage from Germany.

Here on the path leading from a black, invisibly waving poppy field and black ponds to a glass tower, where by day we saw mammoth sunflowers, five and six meters high, dangling in plaster robes, their white roots clawing at the clouds and their plaster-drenched petaled skulls just above the cement floor—here on a nighttime expedition through an art colony of glass, past buildings and factory halls of glass, where earlier today we saw leaden pages of books, tons of them piled high, lying at the ready in a thicket of barbed wire and thorns, saw crinolines, named after French queens and dipped in plaster and bronze, crouching there like empty clam shells—here on our path, all light comes from stars. The May night is calm, cloudless. But peaceful?

Peaceful! As if those raging cyclones of gases and columns of atomic fire up there, down there, out there!, light year upon light year away, those tides of electromagnetic rays and rotating furnaces of hell from a nameless billion-year-old past, those fists of condensing and dispersing matter, clouds pulsing with nuclear fusion and hurling off in all directions… as if this monstrous space, through which whirl spiral nebulae and clusters of stars like dust particles briefly bursting into radiance only to fade again in an icy abyss… as if this entire frenzied spectacle of an infinity's illusory grandeur and permanence could have anything to do with security, with peace and silence. The peace of evening!

It was at dusk, just before we set out into the night, there in that large factory hall, the largest of them, its shadowy outline towered over by treetops now, that we saw a reflection of that nuclear chaos out there: fifteen surfaces of lead foil, painted and hung with plant skeletons doused with plaster, views of the starry heavens—white suns, swarms of asteroids and star clusters, flung, splashed, brushed onto the oiled lead in an emulsion of water color and turpentine, two incompatible elements that repel each other, here thrown together onto a leaden background, and so forced to imitate those chaotic forces, high above our heads, that cause nebulae and Milky Ways to burn for light year upon light year, on into infinity.

The whirling, disbanding firmament, its cataclysm congealed, parched, dried, and finally brought to rest, to a halt—fifteen snapshots of infinity stretched on wall-sized wooden frames and arranged one above the other in rows the length of the hall, a grid of the heavens, three, four stories high …

But then we began to see something familiar emerge out of the blackness of space: white lines among the sparks of stars, vanishing lines, as if drawn with a straightedge or plumb line and connected to the shapes of constellations— *Perseus, Boötes, Scorpius, The Serpent, The Greater Dog*... the tracts of the heavens that, whether out there in space or here in this large hall, were always only sketches, day dreams, projections from both the depths of our conscious minds and the abysses of heaven on a two-dimensional surface black as night, constellations, models, phantoms.

Fludd!—our host calls back a name into the darkness. It was from Robert Fludd, a 17th-century mystic, born in the county of Kent, that he learned to see how every plant, yes, perhaps every organic structure, is coordinated with some figure in the firmament, a macrocosmic analogy for each form found in terrestrial flora—a star for every blossom, every rhizome, every seed of grain.

And so there are plants, too, dangling in front of painted heavenly bodies and nebulae: here a thornbush, brought back from the deserts of Morocco, there a cypress blown down by last year's wind, safflowers, wild roses, the stump of a weeping willow, rhododendrons, each branch, each root in its plaster robe, as if frozen at the moment of its greatest brilliance...

How familiar and out-of-reach Anselm Kiefer appears to us at times on our nocturnal path. Some of us saw him in this same excited state on a scorching day last spring, as he strode through underbrush near the lily pond; back then snow still lay on the peaks and domes of the nearby Cévennes. With a walking stick—or was it just a branch?—in one hand, Kiefer battled his way through the brambles that day, brandishing his stick or branch like a flag, a baton. But it wasn't an entourage that followed him in the dazzling light, it was a bulldozer—*le bull*, as Kiefer's assistants called the beast moving to a conductor's airy signals. It rumbled along just behind our host, cutting its road-size swath by tracing the artist's path—a route determined not by surveyor's plan, but by each new step he took: Here you had to walk or drive around a four-hundred-year-old oak, and there bottomland overgrown with bourbon roses, then on past a plane tree, and on and on between acacias. Kiefer had to plod steadfastly ahead, for rumbling right behind him was *le bull*, and the breach he opened was the bed for the same road through the wilderness that we now followed behind him, ever deeper into the night.

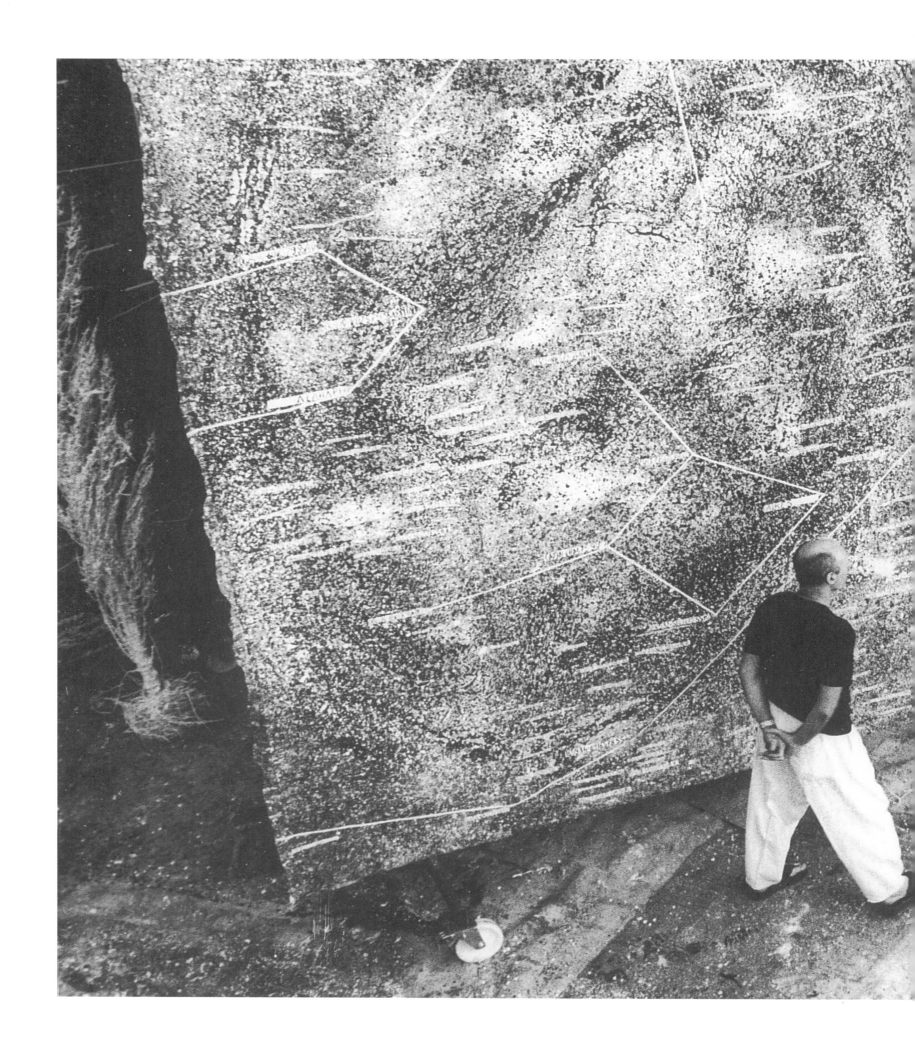

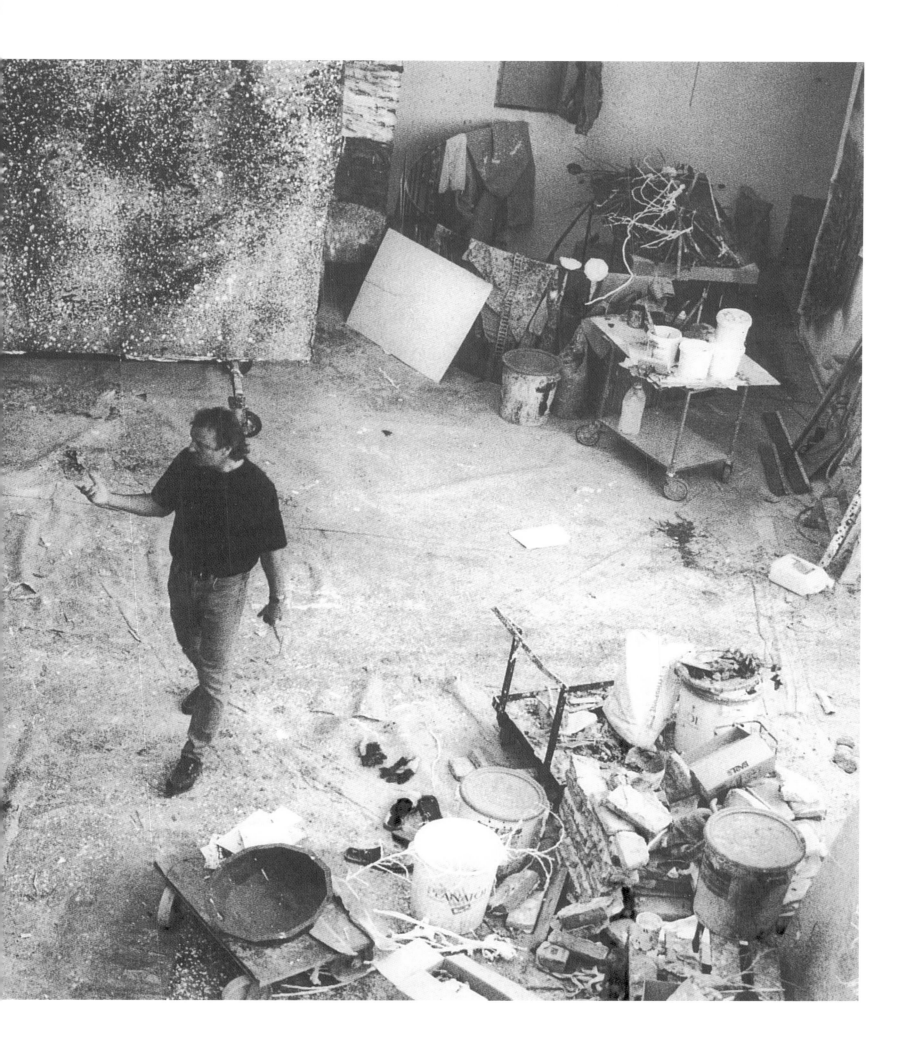

Step by step and then *le bull*! That's how roads, driveways, paths are built at *La Ribaute*, until one day all the glass buildings, gardens, workshops, poppy fields, and ponds will be connected with each other and with the large factory hall, the sixty-meter long residence, the rusting row of a dozen ship containers filled with paintings and sculptures; connected with the iron flying staircase and entrances to tunnels leading down to caverns lined with lead, then flooded, their surfaces reflecting only darkness into darkness—and will all become a labyrinth, ultimately designed to encompass not merely these thirty hectares of land, but also an entire life's work, a tangled route into the wilderness, into land given superterrestrial and subterranean form, paths into the depths of the earth and into heights above, as brutal as life itself.

Bulldozers, overhead cranes, cherry pickers, trucks, steamrollers… as a painter and sculptor, Kiefer long ago stopped working with just brush, spatula, chisel, and pencil; his utensils include construction equipment as well as axes, picks, and flamethrowers, everything, or almost everything else a man needs to turn a piece of land into his land and the world into his world.

At some point, of course, our host's work began a little more gently and on a smaller scale, in studios, darkrooms, and before the empty canvases of an art academy—back then, when years of studying law, Romance languages, and intellectual history at the University of Freiburg had been relegated to the past and contradictory theories, indeed contradiction itself, as taught at academies in Karlsruhe and Düsseldorf, took on significance for an art-student convert. The teachers of this new period were named Peter Dreher and Joseph Beuys. One said: Autonomy! Do what you want, create from the fullness of possibility! The other just smiled: Listen—in art, in the art we conserve, mummify in museums, everything has already happened, already been done. The question now is: What can we do when everything has been done?

Do what you want! Moved by these and other maxims—as easily grasped as they are difficult to carry out—Anselm Kiefer began to play and paint in his studio in the Odenwald region of Baden, began with what was both easiest *and* most difficult, with horror and laughter, on the smallest and grandest scales, not only by employing formats that burst the walls of German living rooms and galleries, but also by entangling miniaturized armies and lead model tanks in confused campaigns on his studio floor,

by sailing shrunken fleets off to sea battles in zinc bathtubs and letting tables and chairs lose hopeless wars—a caricature of the pointless, endless cruelty of the drama that, both then and now, he calls *history*.

We still recall the outrage when, at the end of the sixties in the century just past, he presented to a quickly growing audience a series of black-and-white photographs showing him with an arm outstretched in a *Heil!* pose along the coasts of Europe, on Italian, French, and Dutch beaches—the artist as a small, sometimes vanishing figure before oncoming surf, his face turned toward the jagged waves of the horizon, a little windblown man, enrapt, it seemed, in the absurd and ominous gesture of conquest.

Besetzungen [*Occupations*] was the title Kiefer gave to one series of these documentary photographs, but he would soon learn that in his homeland rituals for remembering the horror had to follow stricter, or at least different, rules from those of a provocative scoffer. Was that permissible—for someone to hail the Atlantic and Mediterranean with the *German greeting* and call up again a past barely survived: the murderous lust and rage of a Nibelung army left charred by a firestorm of bombs? The Hitler greeting extended to the surf!

Even the clamor of frogs on the reed-bound shore of one of the westernmost ponds, where we now stop, is only a gentle chant in comparison to the loud chorus lifted up in Germany as a result of a series like *Besetzungen*. Had it not been for the admiring response and applause from America, the shrill voices of German critics upset by Kiefer's debut might forever have poisoned the artist's fame with their steady drone of accusations that this... this... this painter was stirring up the past with his forbidden gestures, forbidden symbols, forbidden images. Only after voices in Israel were lifted as well to testify that this artist from Germany was to be counted among the just, were people in the land he came from willing to recognize that this tiny, vanishing figure on the beaches of Holland and Italy and France was greeting not a *Führer* and despot, but perhaps, along with the waves, was merely greeting reason, was pointing with his outstretched arm not at triumph, but at the madness of which human beings are capable.

It was not the outrage, not the misunderstandings or often furious attacks, that moved our host to take his leave of Germany, but only what sometimes sends us all on our way, puts us to flight or just off to somewhere else—life's stories and their end-

ings. Kiefer left Germany, traveled year after year, searching in many places for one new place, and at last found it here, in the lee of the Cévennes, at *La Ribaute*. So much remained behind in Germany: studios, art collections, a library, sculptures, paintings, and above all—people: his family, his teachers.

A teacher? No, our host never wanted to teach anyone, never wanted to heal anyone or reform the world. Whom was art meant to serve? What did paintings mean? What did this painting, this sculpture mean? *Think what you want. Do what you want.* Invisible in the dark, Anselm Kiefer speaks from somewhere in the reeds: Here, among the frogs, a new guesthouse is to be built in the next few months. On one of our daytime expeditions we saw a blue rectangle beside the shore here, next to some overgrown ruins of walls, an outline sprayed with blue enamel over ferns and grass. That was a bed, Kiefer replies from the reeds—and has to raise his voice against the song of the frogs—the outline of a large bed in which future guests at *La Ribaute* will sleep. Now we hear him laugh: Only after he has lain here himself, at the shore, in the grass, head here, feet there, where someday the heads and feet of sleeping guests will lie, can what was until then just a plan, a dream house, actually rise out of the reeds.

Buildings. Palaces. Columned halls. We remember Anselm Kiefer in the first years of his worldwide fame: a painter of inscribed, deserted landscapes and fields, a painter of bleak, snow-covered stretches of ruins or gloomily towering architectures of despotism, for which the models had been monumental edifices, columned halls, and monuments sunk beneath the bombed-out rubble of a barbarian regime. Paintings tall as houses, pictures strewn with drifting straw, sand, dirt and hair and brick dust, and sometimes with lines of poetry by Celan or Bachmann scrawled over them: *Awake in gypsy camp and awake in desert tent, the sand trickles from our hair.* Monumental paintings as a mockery of all monumentality, often left for months under the open sky, prey to rain, snow, sun, so that time itself might *paint* and inscribe on what was depicted: What is cannot remain.

Kiefer bored his paintings through with twigs and roses, strewed them with sunflower seeds, organic material easily devoured by mites and even by rats if set out in the courtyard. And desperate restorers wrote letters, hundreds of letters, asking for a varnish or a preservative for the nebulae of seeds strewn across the canvas, seeds that were hollowed out by beetles and now rained down from the painted firmament as

black, dead stars, but that needed to be replaced, preserved, restored—as did the rotting straw and the roses.

Anselm Kiefer made a principle of not answering questions about life span, protection, and permanence, laughed when a gallery owner used gas chambers to rid one entire cycle of paintings from ticks and other parasites or began to grow roses to replace the petals dropping from paintings in a steady snowfall. The painter wanted unfinished, expectant heavens, wanted a snow-covered landscape to be defended at best by cats against rats and mice, and insisted that even the depiction of the sea or the heavens always had to show just one thing: the all-destroying, all-devouring course of time.

But then we remember—while he sets a buzzing remote control aglow in his hands and suddenly three, four glass buildings stand before us in the night like the radiant heavenly palaces—we recall how this painter of transience stepped before us as the creator of leaden libraries, as the author of books made of lead, each a meter or more tall and weighing several tons, and dedicated to conjuring up *Mesopotamia*, *Women Clearing Rubble*, or *The secret life of plants*—books that, when they were showed to us that morning, had to be lifted out of the bookcases with a chain hoist and the help of workers in steel-toed shoes. Our host has made boats out of lead as well and leaden airplane squadrons, close to life-size models of fighter-bombers, that with drooping wings crouch on the floors of galleries, melancholy birds. And finally he had leaden beds built in rooms hung in black—blue-gray resting places whose dimples and dells were for cold puddles that reflect the light of galleries and museums, but never for people.

A friend of lead, definitely. Lead everywhere—in his warehouses, his studios, his courtyards, his life. When the roof of Cologne Cathedral was redone, he had the cathedral's old lead shipped to *La Ribaute* on tractor-trailers, and even he was astounded when the trucks pulled into the large driveway outside his studio—and were empty, or apparently empty, because the legal weight limit of the convoy had already been reached with the incredible weight of lead slabs that barely covered the floor of the cargo space. Pictures, ships, books, bird sculptures, even the meter-high model of a paper airplane that looks as if it were folded by a child and hangs on one of the exterior walls of his studio—all made of lead.

While to the buzz of his remote control even the shoulders of the roads have burst into flame with chains of light that dictate our further path into the night, Kiefer, who

at last has become visible and is ostensibly one of us again, tells us about caldrons of boiling lead, into which he threw boulders in order to watch stone floating in liquid metal. Even a crowbar wielded with all his might could not force the boulders beneath the surface of that roiling primal soup. Floating stones!

Lead, lead everywhere, Latin *plumbum*, symbol *Pb*, atomic number 82, in group 4 of the periodic table, melting point 328° Celsius, boiling point 1740° Celsius, and one of the first metals in human history to be used for killing and adorning human beings. Lead, the metal of Saturn and of melancholy as well.

Lead pipes, conduits, veins, arteries, bouquets of lead. Born in the last days of war, in March 1945, Anselm Kiefer retained memories of buildings burst wide open, leaving visible everything, from cellar to attic, that had previously been roofed over, kept safe and secure: soot-blackened wallpaper, beds full of rubble, floorless living rooms, stairwells without stairs, and above all—these conduits and pipes that seemed to spew like arteries and ragged capillaries from gaps in the walls. Their freshly torn and cut surfaces had a silver cast to them, that in the course of oxidation tended to the gray and blue of much harder metals. These open arteries were visible well into the first years of peace—back in Donaueschingen in Baden, at the confluence of the Brigach and the Breg, at the source of the Danube, the town of his first years.

How beautiful it was among the ruins. As a child Kiefer laid out gardens in the plowed-up soil of a city block reduced to rubble, built houses and dams out of broken bricks and shards, fed the tiny reservoirs of grenade craters with channels of rain- and groundwater, and watched it all be destroyed again by miniature catastrophes, avalanches, and mudslides that cascaded over scrap lumber and charred beams. What a grand exhibition of the real world, where everything at the bottom was upended and burst open and now lay upside down—cellars open to the sky, old-fashioned German living rooms as sooty caves, rusting bazookas, churches with no roofs, playgrounds. It was beautiful. It was a childhood. How grand, how easy it was to build a new world from the rubble of the old—new, but a good deal smaller, too, creation shrunk to sandbox size.

By the diffuse light of the glass tower where we had seen those mammoth plaster-drenched sunflowers hanging like tree-sized pendulums in broken clocks, we spot a black building lying on its roof—by day we had casually taken it for a ruin.

With foundations aimed at heaven's stars, the building resembles those monstrous ears of radio astronomy hoping to hear nothing but the background noise of infinity. Its windows and doors—empty caves. Upside down—our host tells us he had this building, a kind of bunker of poured reinforced concrete, ripped from the earth with a crane and dropped in this grass sprinkled with poppy here, and points now at this building dashed to earth from the heavens—a plumb bob flung from its dangling line.

All of us, our host says as he moves on, really just continue what we began sometime early in our first years: excavate wells and tunnels, build dams and houses, dig caves, models for which we could find deep in our past, dig ditches and canals, flood bottomlands, turn valleys into lakes, and sooner or later toss all our building blocks into a jumble again and start over, playing, forever playing, and yet living with the serious fact of our possibilities, in the middle of the drama of our own violent nature.

How often Anselm Kiefer has made human possibilities the theme of his art, evoking the most cruel and shining figures of so many myths. Stored in those glass buildings gradually retreating from us without losing their luster and in that row of ship containers piled into a barricade are works that tell of ancient Babylonian, Egyptian, Greek, and Germanic heroes—of Osiris, the lord of the dead who was murdered and dismembered by his own brother; of Gilgamesh, the god-man, who slew the heavenly bull and at the bottom of the sea found an anemone that could counter mortality, but lost it again; of Xanthippe, who kept her starving father alive in a dungeon by suckling him at her breast; of Siegfried, the warrior from Xanten, who was bathed in dragon blood, but undone by love…

Kiefer strode through the worlds of Oriental, Mesopotamian, or Nordic myth as if they were buildings and mazes, and upon leaving a structure or a labyrinth, he left behind a chattering or squabbling public—interpreters and apologists, who noticed only too late, if at all, that the artist, the painter had moved on by now, always in search of images that he tried to present and exorcise by every means possible. Every? Many, countless.

In the vaulted cellars beneath the main studio at *La Ribaute* we saw rows of shelves full of crates and zinc chests inscribed with words like: *Catalpa Blossoms, Brown Human*

Hair, Wild Boar Hooves, Shark Jaws, Broken Saw Blade, Driftwood, Rose Campions, Thistles, Horsehair, Hummingbirds, Saber-Tooth Fish, False Coral Snakes, Spined Loaches, Lavender, and so forth, hundreds upon hundreds of things, dried plants and stuffed or dried animals, stones, shells, items he found on trips to India, China, Tibet, and Nepal, to Indonesia and Japan, through both Americas and in the South Seas, always moving onward toward the point of departure—materials that one day became or will become part of a painting or sculpture or drift aimlessly along in the unremitting river of images, flotsam and jetsam, bottle mail from infinity. And at the end of this shelving, where it merged into darkness, we also found a clay pot inscribed with the word *Ashes. Ashes* and *Hay Flowers.*

Ashes and grass. *Grass will grow over your cities,* Anselm Kiefer wrote across one of his leaden books, and a few of us automatically think of how this road along which we have moved through the night—past shining glass buildings, to arrive now at the gate of the large factory hall—will probably also be overgrown again with grass, grass that will start growing the moment mechanized claws have ripped the last roots, loam, and stones from this all-connecting, all-embracing route. And in the green of that future, not one of our footsteps—and at some point no other human voice—will be heard. Over everything that lies beneath the heavens—or so we have understood Kiefer's leaden books to say—over all these roads, paths, and glass buildings lying at last in shards and rubble, over these olive groves that will have sunk back into the earth, grass will grow, until, with the disappearance of the last shard of glass, the last trace of wall, everything will be as it once was without us. More peaceful? Yes, more peaceful. Perhaps.

We have arrived. Our host leads us through the gate open wide to the night and into the interior of the hall lit bright as day. His voice bounces off its walls. The dogs leap around us as if at the end of a hunt, before crouching down, panting, beneath these fifteen segments of the heavens; but once they've caught their breath, they start scrapping again, as if fighting over who will be first to enter the company of constellations: *Castor* and *Pollux.*

Our host says he's glad once a work is finished, glad sometimes, but never satisfied, never! Instead, he has to keep moving on, keep moving on like anyone who has not yet arrived—maybe even like someone who has not yet been brought entirely into this world; always moving on.

Here in the largest building at *La Ribaute* are Kiefer's most monumental paintings—seas, leaden waves of rose and poppy fields, of firmaments towering nine, ten meters and higher into the light.

Large? Monumental? What does that really mean? Something can be large only in relation to something else, but never large or small on its own. How large is a painting ten or eleven meters tall, if its size isn't determined by a living room or a gallery, but solely by its theme and passion? How large are Kiefer's paintings, for example, in comparison to the black ridges of the Cévennes, out there in dark distance beyond this hall, or in comparison to the dizzying view into the meandering ravines of the nearby Ardèche, which has dug its bed hundreds of meters into the limestone, leaving behind spring-fed caves high above its gravel beds and foaming cataracts, a suite of gigantic stone halls. Murals more than thirty thousand years old were discovered there, paintings whose creators used the colors of iron oxides to work the wonderfully flowing lines and cracks in the natural structure of the stone into rhinoceroses and bison, into hyenas, cave bears, and mammoths… into a bestiary whose age and approximate millennium of origin could be determined only by those clocks of physics that measure the decay rate of an isotope of carbon. How large or small can works of art be in the presence of reality's dimensions—or according to the scale of our dreams?

In addition to the fifteen tracts of the heavens that tower into the roof beams of the hall and before which the dogs' scuffle has ended in a draw is another painting, *Shevirat Ha-Kelim*, nine meters high and five meters wide, which bears shards of clay vases and tells the story of the *Breaking of the Vessels*: an overpowering work of art that transports us deep within the Lurianic Cabala, into the heart of the mythic catastrophe during which the vessels of divine light burst open and all light was scattered as swarms of sparks and now, as mere reflections trapped inside the shards of evil, await liberation to rejoin their origin, their radiant source.

A few of us have seen this tower of a painting in an exhibition in the *Chapelle de la Salpêtrière*, the great Paris hospital where, over the centuries, sick, despairing, and dying patients prayed to be healed or at least to be received into heaven, prayed for paradise. In vain? Who knows.

Next to the *Breaking of the Vessels*, the tracts of the heavens rise up like a promise: fifteen lead segments, each tract of this firmament an example of the boundless spaces

in which Anselm Kiefer searches for his images. And amid these galaxies flung onto lead are details as well—high up, just below the roof, visible only with binoculars: white suns, swarms of asteroids, thousands of heavenly bodies, and, beside them, names of stars in white characters, combinations of letters and numbers, the codes by which astronomers try to deal with these swarms of sparks in the darkness. One of us peers into these heavens through his binoculars and reads aloud:

144615+173237655kOdTAU

and

211448+3803373SDF0tCYG

and

033256-0928373SSK2eERI

and

053845-0236373D09sORION

and so forth, unpronounceable, mathematical names, that contain the coded stories of astronomical discoveries and reflect the poetry of ancient astral calendars, but only in their suffixes: TAU – Taurus, The Bull, CYG – Cygnus, The Swan; and Eridanus and Orion and…

And among all these stars and characters we can also see, without telescopes or binoculars, little leaden shirts, some no larger than the finger of a girl's hand, others the size of newborns or dolls, all sewn according to the painter's pattern by an Algerian seamstress in Barjac, who sorts them by size and delivers them to his studio, where they wait in paper sacks, hundreds of leaden gowns, wait until Kiefer attaches them to the firmament. And amid all the names of constellations that we know from celestial atlases, we also read in white letters the names of those for whom these leaden shirts were sewn: *The Unborn.*

The diversity and size of reality, our host says, almost vanishes before the endless columns of sheer possibility; and even the numbers of those dead and those born vanish when measured against the numberless unborn. How marvelous, our host says, is this sheer possibility, everything still waiting to be given form, to be realized and perfected, both here in our lives and out there, in space, marvelous—and he turns toward the black mouth of a tunnel that leads out of the large hall and into the earth's interior, into depths where lie blind corridors, thrust almost playfully, it seems, into the

realm of earth, and chambers lined with lead, flooded caverns, their surfaces reflecting only darkness into darkness.

It is down into them, into a darkness in which every ray of light, every spark appears as a revelation, that Kiefer now wants to lead us. But even before we realize his intentions, the dogs stand up as if responding to a sudden, soundless command. They do not know the goal either, know only that it is time to leave, to move on, out into the night or down into the depths, and barking loudly they storm ahead of their master.

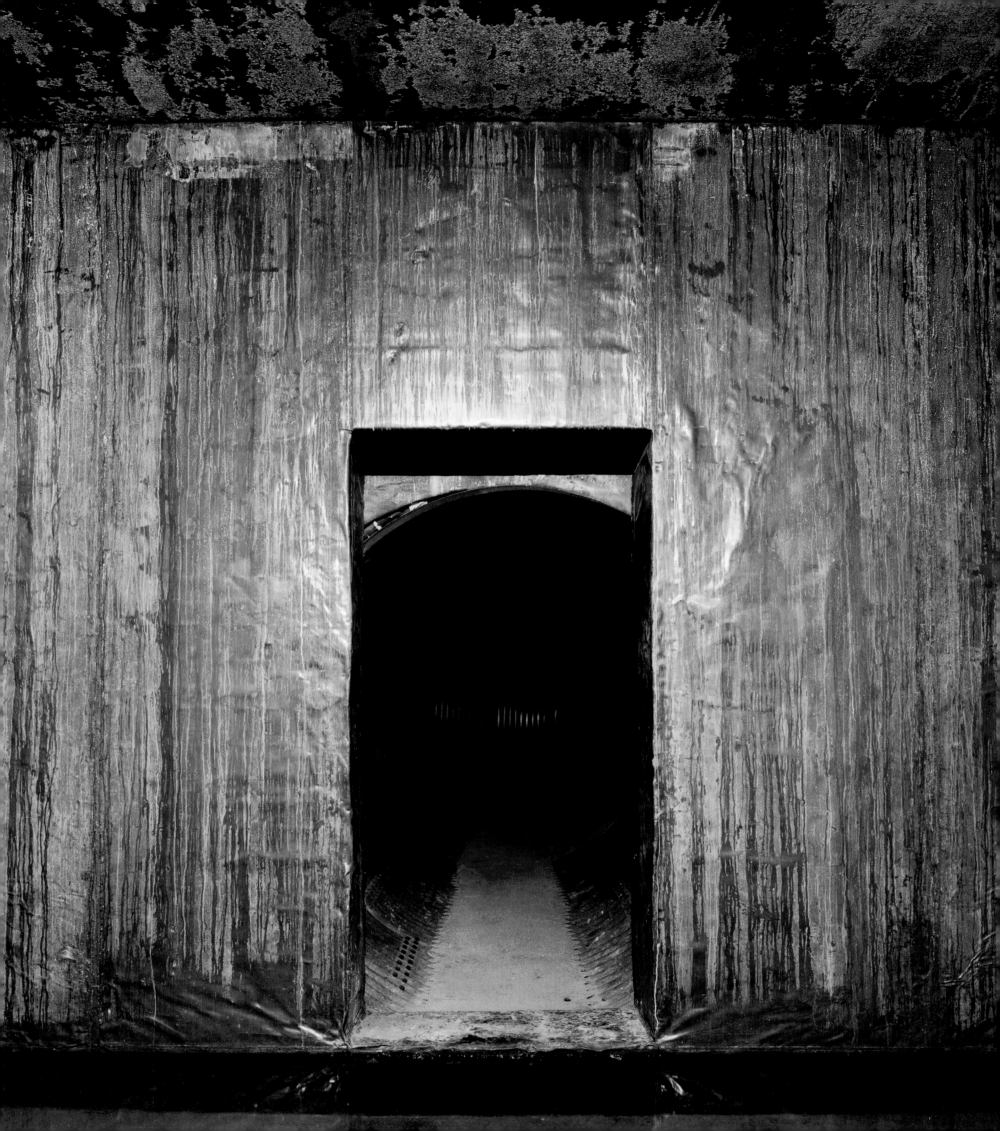

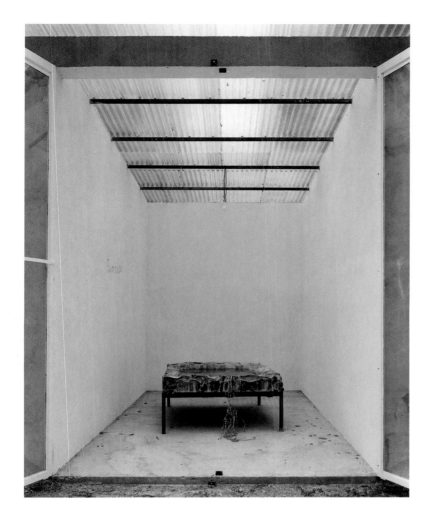

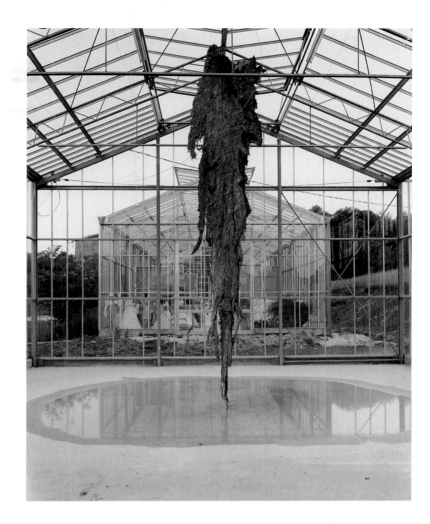

Thomas Flechtner: Views of Anselm Kiefer's Studio Compound,

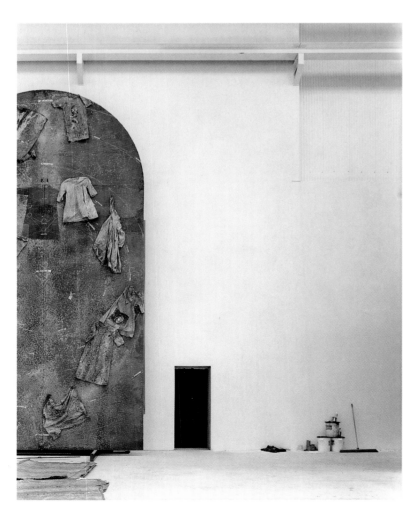

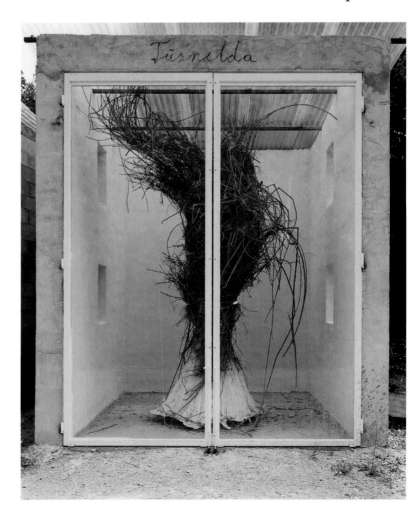

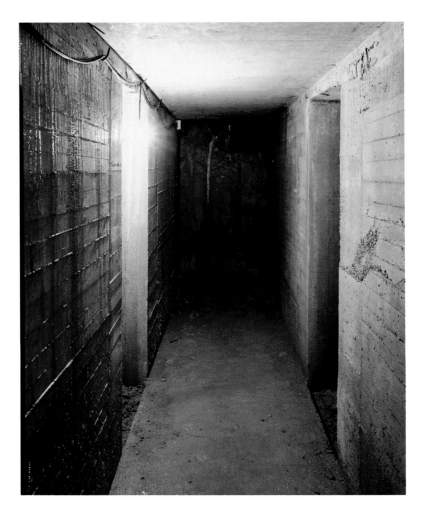
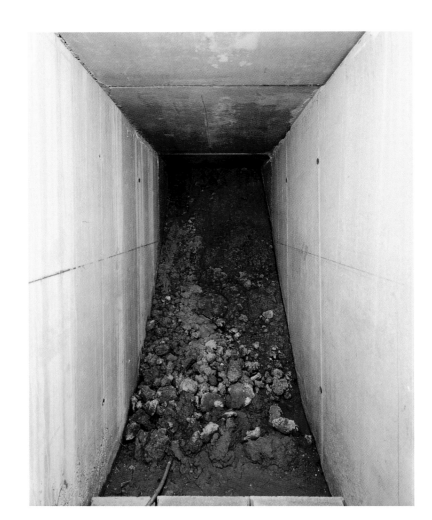

La Ribaute near Barjac, France, June 2001

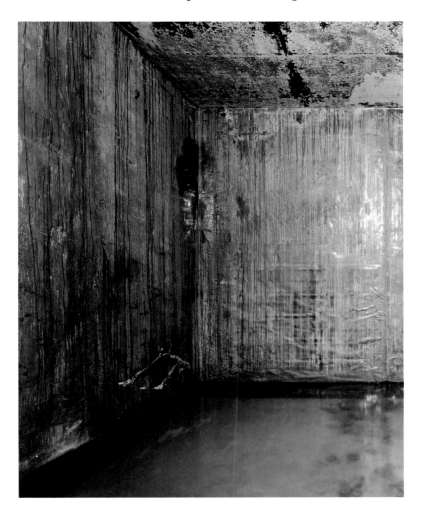
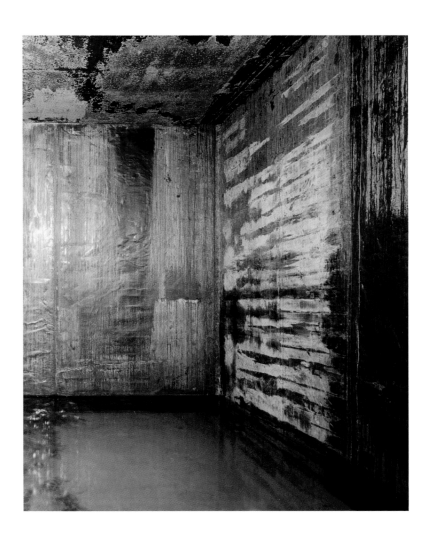

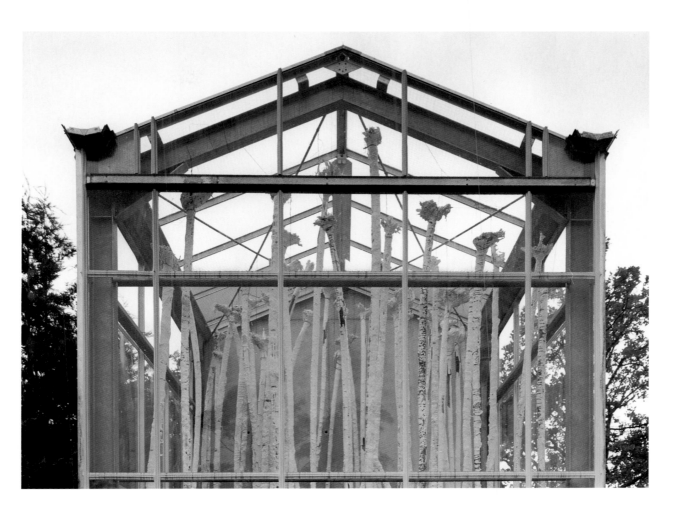

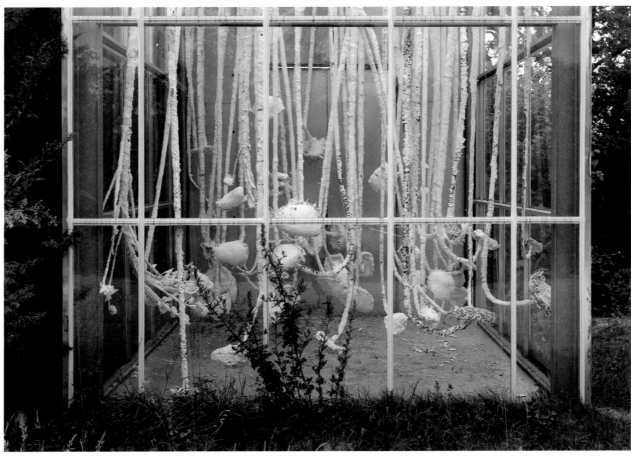

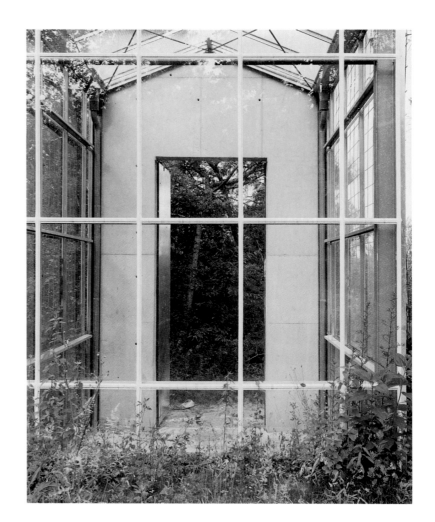

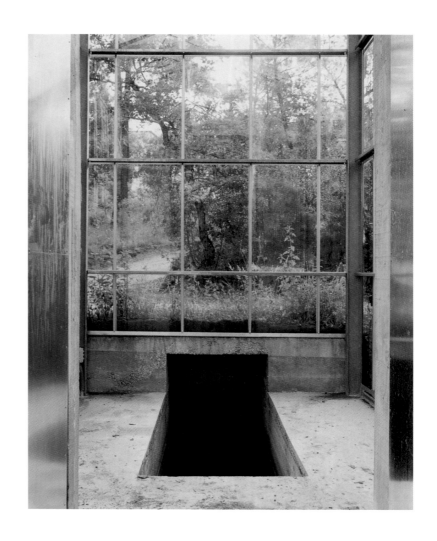

The Exhibition "*t*he Seven Heavenly Palaces"

He lay unmolested in the night, below him the wide, flat sea and the invisible coastline, and he had the feeling that his shoulders, his back, his whole body was clinging to the vault of some vast room and that he was no longer looking up at the stars, but down into bottomless deeps filled with billions of hovering sparks.

Christoph Ransmayr, The Last World[1]

At the end of our journey through the exhibition "*t*he Seven Heavenly Palaces"—a title taken from the Jewish *Hekhalot* literature—we come to a vast, Cinemascope-sized painting of thousands of white dots on a black ground. It is a radiant firmament of stars, which cluster towards the centre to form a Milky Way and are connected by straight lines to form imaginary constellations. Here, the endless expanses of the universe are captured on the tangible surface of the canvas: *Lichtzwang*, 279.5 x 759.5 cm (*Light Compulsion*, 1999, cat. 20, pp. 80–81). At the beginning of the tour, the visitor encounters the cramped, wooden enclosure of an attic room, its exit barred by a panelled door: *Die Tür*, 300 x 220 cm (*The Door*, 1973, cat. 1, p. 45). The distant view of myriads of sparkling stars contrasts with the close-up view of the precisely painted wood grain of the larch boards that compose the interior. What a contrast!—Or, rather, what a distance Anselm Kiefer's work has covered since he returned, long ago, from his legendary *Besetzungen* (*Occupations*)[2] of Switzerland, France and Italy and set up his studio in the attic above the former schoolhouse at Hornbach in the Odenwald.

Kiefer's works have been much debated, not to say denounced, on account of their provocative quotations from Germanic sagas and Christian epics, and of the artist's interest in Wagner and Wagnerism and in the potency of National Socialist architecture. They have been variously characterized as ambivalent taboo-breaking, as a grieving process in paint, as a revival of mythological subject matter, and as the "rehabilitation of a nationalistic repertoire of ideas".[3]

Since his Odenwald days, however, and above all since his move from Germany to the South of France, Kiefer's work has broadened in its scope. From his earliest cycle of paintings, the Dachboden-Bilder or Attic Paintings—interiors heavily laden with Christian and pagan mythological events—it would have been impossible to predict the wide thematic spectrum of the spaces for recollection that he has subsequently created.[4] It is, therefore, well worth reconsidering the work of those early phases in the light of what has happened in his work since. The Anselm Kiefer who emerges from this process will not be a painter of past events so much as an architect of spaces: of places in space-time that can be entered and experienced here and now. Susan Sontag has identified this "panoramatic" treatment of time in space as a recurrent model in the epistemology of Walter Benjamin: "To understand something is to understand its topography, to know how to chart it. And to know how to get lost ... Time does not give one much leeway; it thrusts us forward from behind, blows us through the narrow funnel of the present into the future. But space is broad, teeming with possibilities, positions, intersections, passages, detours, U-turns, dead ends, one-way streets."[5]

In Kiefer, the multiplicity of space is reflected in a wide diversity of differing spaces: poetic (*Sulamith* [*Shulamite*], 1983, cat. 13, pp. 60–61, after the poem "Todesfuge" [Death Fugue] by Paul Celan); mythical (*Parsifal*, 1973, cat. 3, pp. 42–43); ritual (*Die Tür*, 1973); this-worldly and other-worldly, inner and outer (*Resurrexit*, 1973, cat. 4, p. 41); archaic (*Der Sand aus den Urnen* [*The Sand from the Urns*], 1997, cat. 16, pp. 70–71), epochal (*Dein und mein Alter und das Alter der Welt* [*Your Age and My Age and the Age of the World*], 1997, cat. 15, pp. 68–69); intimate and at the same time cosmic (*Lichtzwang*, 1999). The architecture of pictorial space—as in the internal perspective of the attic studio or the stone courtyards—is charged with associative spaces of ideas and meanings by the addi-

Passages through Worlds and Cosmic Spaces

tion of inscriptions in a distinctive, awkward-looking script. Spaces, for Kiefer, are vessels that can be emptied and filled with different memories and ideas. He thus transforms the neutrality of architectural and topological space into the specificity of place: a Here and Now. The empty studio space becomes the sacred place, in which, here and now—or just a moment ago—the act of sacrifice is or was performed, as documented by the hare's pelt stretched out on *Die Tür*. At the same time, Kiefer—such is the dialectical sophistication of the artist-philosopher—always presents the metaphysical act of visualization as an act of model-building and of painting. The weaponry of war in *Bilder-Streit* (*Iconoclastic Controversy*, 1980, cat. 6, p. 49) can readily be recognized as a photograph of toy tanks set out on the stone floor of the studio. For the viewer who reads the title, this evokes a depth of meaning that is simultaneously negated by the miniaturization of the visual motif. Out of the material mined from the quarry of myth and cultural history, the artist constantly constructs new spaces—which he traverses, only to cross some new threshold and reach new places that "belong to a foreign land and a distant time" (Heiner Bastian), or else to the field of poppies just outside the studio at Barjac.

Since 1993, Anselm Kiefer has been transforming his 35 hectares of land at the foot of the Cévennes into a construction site, where he creates an artistic landscape that can literally be entered: a continuation of painting by other means.[6] Sheds and glasshouses, scattered across the wilderness as ideal containers for paintings and sculptures, form three-dimensional, walk-through tableaux with underground or overground access.

Kiefer's panorama of spaces and places that can be experienced and traversed in the imagination—and, at Barjac, in literal reality—seems ultimately to focus on the quest for the one, single space. Rainer Maria Rilke once spoke of the "cosmic inner space" that "extends through all beings"[7]—a curious metaphor, since space surrounds beings and does not extend through them. When asked about the underlying theme of his art, Kiefer uses the metaphor of a volcanic crater: "All painting, but also literature and all that goes with it, is always about walking around something that cannot be said—a black hole or a crater—something you can never get to the centre of."[8]

But how can this all-embracing and all-pervading space be conveyed spatially? The work done on the La Ribaute studio compound—which is unified by its complex of above-ground and below-ground pathways, and overarched in real space by the vault of heaven—comes close to the idea of a single, immeasurable world or cosmic space. The scattered network of buildings itself, however, comes still closer to the complex image of the Labyrinth—which is how it is experienced. The only way to resolve the problem is to add a vertical axis of time: "I think in vertical terms," Kiefer admits, "and Fascism was one of the levels. But, I see all the layers. In my paintings, I tell stories in order to show what lies behind history. I make a hole and pass through."[9]

The creation of a horizontal panorama of time in space is overlaid by the visualization of history and myth in the present; the result is an archaeological stratification: "I am also a sediment. I am around 2,000 years old. And so the deposits that accumulate on the canvas over the years, in the course of the production process, correspond to the strata of human and geological history ... Two kinds of time correspond to each other: 'small-scale', individual human time and 'large-scale', cosmic time. An osmotic relationship, with the canvas as the membrane."[10]

These two aspects—panorama and stratification, the horizontal and the vertical—interlock to form a cosmic model. The cohesion of Kiefer's works adumbrates a basic cosmological structure in which spaces

enclose each other like Russian dolls. From a centre—the "black hole"—everything appears spatially discrete and yet simultaneously available for experience: the macrocosm is reflected in the microcosm; inside becomes outside, and vice versa. This simultaneity of the non-simultaneous, this concentration of space in a single place, is the true and—it must be said—metaphysical nucleus of Kiefer's artistic impulse.

This is like reaching the centre of the crater: it is an impossible construct, and the artist knows it. He applies the same ambivalent awareness to the question of meaning itself: "The artist produces a connection that no one else can produce. He sets up meaning by making something meaningless…Of course, by equating or opposing something to cosmic meaninglessness, I create meaning. But it is a meaningless meaning, a seeming meaning."[11]

Cosmic unity has been lost from the collective world-view; hence the impossibility of interlocking space and time, as discussed above, within a spherical cosmic model. Medialization has long since broken down the "wholeness of the universe" into a "pluriverse" (Peter Weibel) of subjective worlds. The French philosopher Jean Baudrillard takes this further: since the speed of information and transportation technology has abolished space, he speaks of the "fractal object": one that no longer either suggests a pre-existent totality—in the way that a ruin does—or forms a whole that transcends its component parts, but instead is replicated, complete, even in the smallest of those parts.[12] The artist, the individual, can experience this pluriverse only by stationing himself at a single point and extending the cosmos of his own perceptions, thoughts and feelings from that point—as Kiefer does in the last painting in this exhibition. In *Sol invictus* (1995, cat. 14, p. 91), the figure of the artist himself makes its reappearance, for the first time (aside from a scattering of photo pieces) since signing off with *Mann im Wald* (*Man in the Forest*) in 1971. Beneath a sunflower bloom that reaches up high like a street lamp, the artist lies gazing up into the array of dark seeds that look to him like a night sky. Seeds fall like stardust from the protective plant, and the figure is plunged into a chaotic vortex. The painting bespeaks the pantheistic longing to be subsumed into a cosmic whole. Yet, this consolation is dispensed to the

lost denizen of the cosmos—the fractal subject—by nothing more than a shrivelled sunflower, shedding its last seed. Looking on at this extraordinary scene of fertilization, we can empathize, and yet we remain outside. This simultaneity of inside and outside is typical of Kiefer the "two-component technician",[13] who in a 1990 interview had this to say of the elusiveness of goal and meaning in artistic endeavour: "By going in, you experience the world at first hand, but you have no consciousness of it. So you have to step back again, and after that you do have a consciousness of what happened before."[14] This is the topological contradiction described by Jacques Lacan in terms of the ambivalent relationship between man and language: man inhabits language, and language inhabits man. Similarly, in Kiefer's spaces and images, the viewer inhabits the images, which also inhabit the viewer.

So transparent and so exposed is this last painting that it clearly illustrates "how thin is the ice" (Kiefer) traversed by the artist who, in this age of medialization and implosion of space, ventures onto the borderline between cosmos and chaos to address such fundamental experiences as myth and history. Let us launch into Kiefer's worlds and cosmic spaces, which always also define frontiers. To encounter those spatial frontiers, says Martin Heidegger, is "to be overcome by what Goethe called a trepidation akin to dread. For there seems to be nothing beyond space to which it [space] might be referred."[15]

This exhibition concentrates on Kiefer the architect, arranging spaces like an enfilade of rooms that extends ever deeper: from the narrow confines of the Attic Paintings to the half-open Stone Halls, and on to the archaic, megalithic architecture of the Maya and Egyptians, with simple brick stoves from India standing in for the forms of the original structures. Ultimately, the eye crosses the horizon and rests on the drifts of stars, mapped out with numerical labels[16] and geometricized by connecting lines into a celestial architecture, before finally reconnecting heaven and earth in the monumental sunflower paintings. The construction is based, throughout, on the rectangle of the easel painting. There, centralized perspective creates illusory spaces that acquire a kind of material presence through the painter's intensive application of sand, clay, straw, paper and lead. The passage

through the paintings, as documented and described in the catalogue section below, takes place beneath the crystalline glass roof of Renzo Piano's building, which itself, for the duration of the exhibition, becomes a "Heavenly Palace".

Markus Brüderlin

1 Christoph Ransmayr, *The Last World*, English translation by John E. Woods, New York 1990, p. 176.
2 In 1969, Kiefer travelled to a wide variety of historic sites in Europe and there made public appearances with arm raised in the Hitler salute. This political performance piece was recorded in photographs, which the artist later modified.
3 See Sabine Schütz, *Anselm Kiefer – Geschichte als Material: Arbeiten 1969–1983*, Cologne 1999, p. 171.
4 In a recent interview, Kiefer confesses: "no one wants to go on and on along the same tracks. I didn't want to turn into a Holocaust specialist." Interview with Heinz Peter Schwerfel, *art* 7 (2001), p. 26.
5 Susan Sontag, "Under the Sign of Saturn", in Sontag, *Under the Sign of Saturn*, New York 1980, pp. 116 f.
6 Cf. Christoph Ransmayr's essay, pp. 11–25.
7 "Weltinnenraum, [der] durch alle Wesen reicht". Rainer Maria Rilke, "Es winkt zu Fühlung fast aus allen Dingen", in Rilke, *Ausgesetzt auf den Bergen des Herzens*, Frankfurt am Main 1975, p. 87.
8 Kiefer continues: "… and whatever themes you take up, it's always rather like little stones at the foot of the crater–trail-marks in a circle that hopefully closes in ever more tightly around the centre." Interview with Axel Hecht and Alfred Nemeczek, *art* 1 (1990), pp. 40 f.
9 Quoted from Schütz (as note 3), front flap of jacket.
10 Hecht/Nemeczek interview (as note 8), p. 48.
11 Hecht/Nemeczek interview (as note 8), p. 43.
12 Jean Baudrillard, *Subjekt und Objekt – fraktal*, Bern 1986, p. 6; also, p. 5: "Transcendence has exploded into thousands of fragments, which are like the fragments of a mirror, in which we catch a glimpse of our own face, our own image, just before it disappears."
13 See Jürgen Harten, in *Anselm Kiefer*, exh. cat., Städtische Kunsthalle Düsseldorf, 1984, pp. 41 f.
14 Hecht/Nemeczek interview (as note 8), p. 43.
15 Martin Heidegger, *Die Kunst und der Raum*, St. Gallen 1983, p. 7.
16 The codes pasted onto the painting are taken from a NASA list; each contains information on the physical properties of the star in question.

I Attic Paintings 1973

Markus Brüderlin

In 1973, Kiefer produced the painting *Resurrexit* (cat. 4, p. 41), which is almost ten feet high. It has an evident bipartite division. The basic image, approximately square, is a leafless woodland scene with a firebreak that draws the eye on into the distance; above this, a pyramidal superstructure conducts the gaze up a steep staircase to a closed, wooden door. Behind the door is the studio into which the artist moved in 1971, to work "between heaven and earth" in the roof space of a former schoolhouse at Hornbach in the Odenwald. *Resurrexit*, "He is risen", is the message of Easter. Is Kiefer associating his move to a new workplace with the Christian message of salvation? The same staircase appears in a work of 1980, an overpainted photograph, in which *Des Malers Atelier* (*The Painter's Studio*; cat. 8, p. 40) appears to be under threat of destruction by fire: After the Christian sequence of crucifixion and resurrection, the tongues of flame evoke a different kind of ritual action, with which Kiefer associates the work of the artist. In a landscape painting, *Malen=Verbrennen* (*Painting=Burning*, 1974), the outline of an artist's palette hangs over a fallow field. Katharina Schmidt interprets this not as a self-inflicted process of attrition or destruction—as evoked in the landscape series *Verbrannte Erde* (*Scorched Earth*)—but as a metaphor of phoenix-like renewal.[1] By contrast, for Mark Rosenthal, the image of the staircase menaced by flames alludes to the physical magic enacted in alchemy: "purification, filtration, and concentration".[2]

"Concentration" was also the motto of Kiefer's intensive, yearlong bout of creativity in 1973, when, living in his remote seclusion, he produced ten or so masterworks that laid the foundations of his pictorial universe. These paintings will be re-examined here in the light of his more recent work.

Up the stairs, we discover in the painting *Die Tür* (*The Door*, cat. 1, p. 45) a further analogy between artistic creation and a religious process: in this case, that of sacrifice. A real hare skin is stretched out on the panelled door, and the painted floorboards carry flecks of red paint that allude to the sacrificial act. Kiefer nails the hare's remains to the canvas, like a blank pictorial support within the painting. *Wie man dem toten Hasen die Bilder erklärt* (*How to Explain Pictures to a Dead Hare*) was the title of a performance given by Joseph Beuys at Galerie Schmela in Düsseldorf in 1965. The obvious reference to Beuys, and to Actionism, serves partly to demonstrate Kiefer's closeness to Beuys's "expanded definition of art". When Kiefer concentrated his energies on painting, this did not mean that he had relapsed into a traditional medium while the avant-garde pressed on into Performance Art and Land Art. By "withdrawing" into the intimacy of the Attic Studio, he was certainly not turning his back on reality and on the present day. On the contrary, it is clear that the Attic Paintings were the germ of an artistic conception that explored remote spaces of history and myth before laying those spaces out in terms of real presence through site-specific installations such as that of his current compound at Barjac in France.

Kiefer's Attic Paintings are large works in charcoal on oil and acrylic on burlap, or in oil on woodchip paper on canvas or cotton duck. They show the interior of Kiefer's studio, in precisely constructed perspective, with a slightly raised viewpoint. Katharina Schmidt speaks of "a uniform scenic décor of archaic-looking interiors, which can as readily absorb pagan and Christian mythologies as a [refined bourgeois] commemorative shrine for *Deutschlands Geisteshelden* [*Germany's Spiritual Heroes*]".[3] These paintings attracted controversy through their "Teutonic" atmosphere[4] and their references to Richard Wagner's version of the German blood myth. *Parsifal* (cat. 3, pp. 42–43) is the title of a wall-sized triptych that, together with the related composition *Notung* (cat. 2, pp. 46–47), is due to turn the narrow Room 17 of the Fondation Beyeler

into an attic. In his opera *Parsifal*, Wagner set the Grail legend to music, basing his libretto on the thirteenth-century courtly epic *Parzival* by Wolfram von Eschenbach. Parzival, a king's son, becomes a hero when, in the Grail Castle, he succeeds in posing the correct, redemptive question and in healing the wound of Amfortas, custodian of the Grail. *"Höchsten Heiles Wunder! Erlösung dem Erlöser!"* ("Miracle of highest salvation! Redemption to the Redeemer!") is the text on Kiefer's eponymous painting, now in the Kunsthaus Zürich. The triptych, with its attic supported by massive beams, shows on the left the bed on which Parzival sleeps as a boy, on the right his sword, planted in the wooden floor, and in the centre a spear. Aside from these three props, the space is empty. A line of text along the lower edge elevates what looks at first sight rather like a deserted nursery into a place of sacred ritual. The line *"Oh, wunden-wundervoller heilger Speer!* ("O wound-wonderful holy spear!"), and a number of names including those of Herzeleide, Parzival's mother, and Gamuret, his father, serve as reminders of the absent characters in the epic. Kiefer's interpreters have long since concluded that his involvement with the Germanic sagas and with the aesthetic of National Socialism is not a revival of "Teutonic mythomania" or of the Romantic genius cult: his strategy is one of "affirmation", seeking to overcome the disease by repeatedly enunciating its symptoms.[5]

In the Attic Paintings, one component of this ambivalent affirmation is the tension between the emptiness of the spaces and the palpable atmosphere generated not so much by the rather sparse props (other paintings include a chalice, studio chairs with burn marks, etc.) as by the plainly handwritten names and titles that have been added. Jürgen Harten speaks of Kiefer's use of a "two-component technique" to touch the nerve of contradiction. The profundity implicit in the title is brought down to earth by the ordinariness of the things that are painted, and vice versa. "Often he leaves paintings ready and waiting for a word; less frequently, he leaves a word to find its own painting", says Harten.[6] The writer Christoph Ransmayr, on the other hand, as a man whose business is words, views the interaction between concept and image the other way round. Kiefer, he says, examines literary myths for their suitability for translation

into painting. What was there "in the beginning", the word or the image? We know from imagination theory that word and image evoke each other reciprocally. Kiefer uses this mechanism to gather time past into the vessel of his wooden interiors, and to translate it into the foursquare space of a painting.

In itself, the poetic image of the word *Dachboden*, meaning attic or loft—synonymous in German with *Speicher*, store or memory—illustrates a translation of time into space. With the literature of Romanticism in mind, Walter Grasskamp speaks of an attic as a "place of suppression", but also of "recollection".[7] There, the occupants of the house stow the objects they no longer use; there, too, the discreditable heirlooms of German history lie in store. Up in the attic, the inquisitive seeker may find past time and memories—just as a child, poking around in the lumber-room, may find in the microcosm of family history a first, dawning awareness of the macrocosm of collective memory.

Kiefer has painted the grain of the planks with ostentatious care, as if to make the flux of time visible in the cross-sectioned growth rings. The presence of the wood—here still suggested by illusionistic means—foreshadows the highly charged use of "literal" materials in the artist's later works in series, moving from ever more densely impasted paint by way of straw, charred wood, sand, lead and clay to the symbolic use of plants. The material of the work appears as the sediment deposited by time and is charged with a spiritual content. The philosopher Henri Bergson asked himself (in *Matière et mémoire* [1896], London 1911) where the past can be found: in brain or body, mind or matter. His answer was that it is in neither: memories are complex states of space, in which things and materials are held in an order imposed by mind.

Another way in which time can be spatialized resides in the interaction between remoteness and closeness. The metaphysical remoteness conveyed by the ritualistic objects and inscriptions, and the material closeness of the seemingly blank, ordinary boards, confer a powerfully defined aura on the work as a whole: "The aura," wrote Walter Benjamin, "is the appearance of remoteness, however close may be the thing that generates it." He contrasted this with the "vestige" (in German, *Spur*): "The vestige is the appearance of closeness, however remote may be the thing that left it …

In the vestige we take possession of the thing; in the aura it takes possession of us."[8] We glimpse remoteness in the forest firebreak that recedes into depth beneath the narrow attic stairs in the painting *Resurrexit*. Closeness and remoteness are here visually presented in the interlocking of interior and exterior. In the period that followed, Kiefer began to paint flat, open landscapes. Furrows in ploughed fields, viewed in accelerated perspective, track the "vestiges" of remote events up to the close, lower edge of the image.

It was before the end of 1974 that Kiefer produced his first landscape painting, *Grab des unbekannten Malers* (*Tomb of the Unknown Painter*; cat. 5, p. 48). This was the first work to give visual expression to the "deep analogy between the painter and the Unknown Soldier" (see the following chapter). Walled in by trees that are barely recognizable as such, this is an exterior that conveys the atmosphere of an interior. Amid the all-over effect of a grey snowstorm, we discern a forest graveyard with a simple wooden cross—a reminiscence of Caspar David Friedrich's *Graveyard in the Snow*. To a wonderful degree, this work evokes the novelist Adalbert Stifter's account of the subjective sense of space amid falling snow: one feels as if suspended in an empty space, wrapped in a "uniform white darkness",[9] exposed to a consuming void, under constant threat of toppling into nothingness.

If it is true that behind Anselm Kiefer's pictorial time travel and his scrutiny of myth stands the exploration of space, then the Attic Paintings afford direct access to the cosmos of spatial reality that is—according to Susan Sontag—the elementary point of access to the understanding of anything.[10]

1 Katharina Schmidt, "Anmerkungen zum Werk von Anselm Kiefer", in *Anselm Kiefer. Bücher und Gouachen*, exh. cat., Hans-Thoma-Museum, Bernau/Black Forest 1983, n.p.
2 Mark Rosenthal, *Anselm Kiefer*, exh. cat., The Art Institute of Chicago, Philadelphia Museum of Art, The Museum of Contemporary Art, Los Angeles, and The Museum of Modern Art, New York, Chicago and Philadelphia 1987, p. 115.
3 Schmidt (as note 1). *Deutschlands Geisteshelden*, 1973, 307 x 682 cm.
4 Sabine Schütz has attempted to draw aesthetic parallels with the interiors of showpiece Hitler Youth hostels and with the *Heimatschutzstil* or "Home Country Protection Style" of the National Socialist period. Sabine Schütz, *Anselm Kiefer – Geschichte als Material: Arbeiten 1969 – 1983*, Cologne 1999, pp. 190 ff.
5 Bazon Brock, "Avantgarde und Mythos. Möglichst taktvolle Kulturgesten vor Venedigheimkehrern", *Kunstforum International*, vol. 40 (1980), pp. 96 f.
6 Jürgen Harten, in *Anselm Kiefer*, exh. cat., Städtische Kunsthalle Düsseldorf, 1984, pp. 41 f.
7 Walter Grasskamp, "Anselm Kiefer. Der Dachboden", in Grasskamp, *Der vergeßliche Engel. Künstlerportraits für Fortgeschrittene*, Munich 1986, p. 14.
8 Walter Benjamin, *Das Passagen-Werk, Gesammelte Schriften*, vol. V.1, Frankfurt am Main 1982, p. 560.
9 Adalbert Stifter, "Bergkristall", in *Bunte Steine*, Munich 1951, pp. 188 f.
10 Susan Sontag, *Under the Sign of Saturn*, New York 1980, p. 116.

8 Des Malers Atelier, 1980 *The Painter's Studio*
Chalk, graphite pencil and acrylic (or oil) on photograph (1971), 58.5 x 68 cm

4 Resurrexit, 1973
Charcoal, oil and acrylic on burlap, 290 x 180 cm

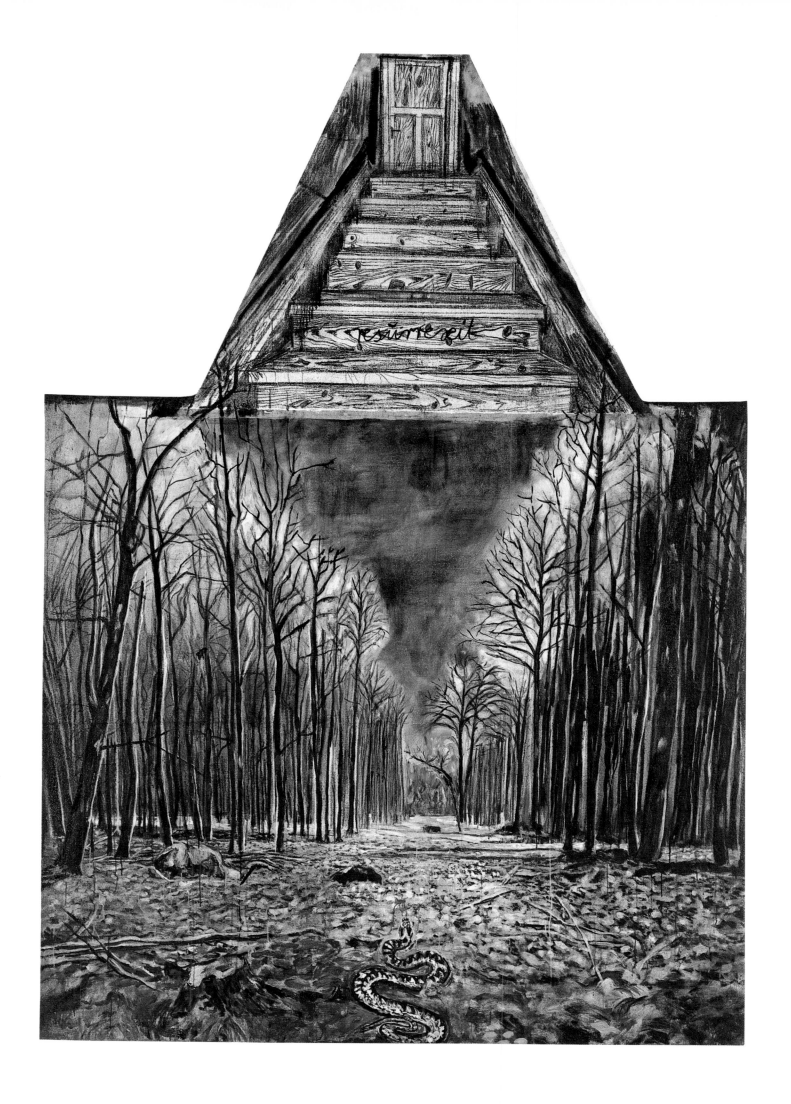

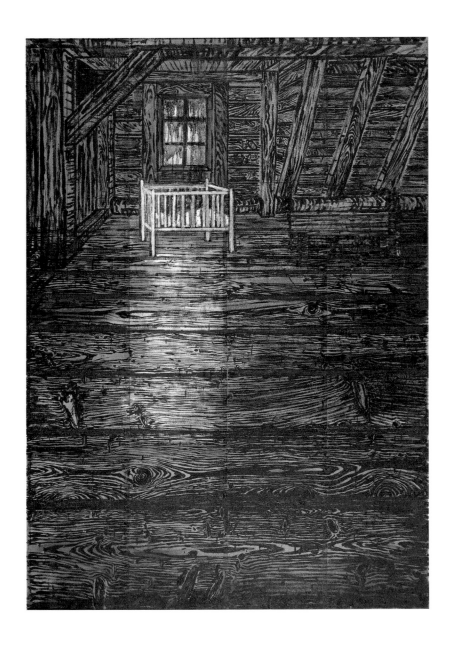

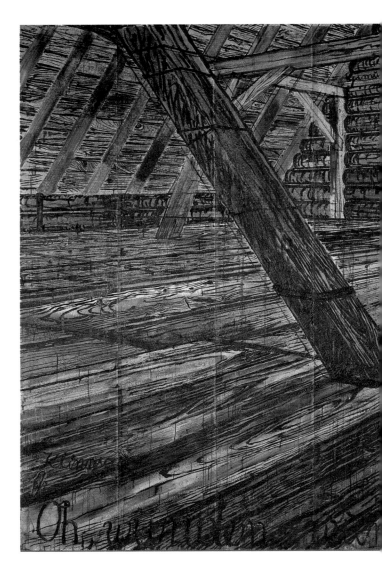

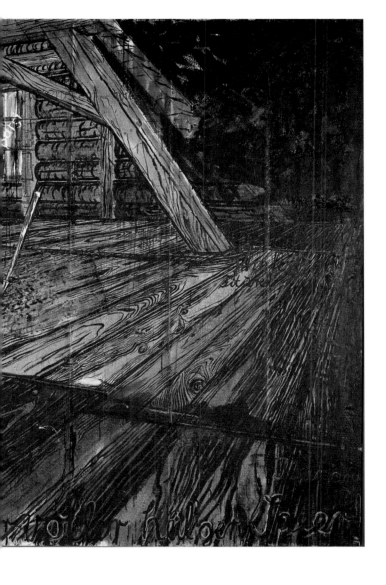

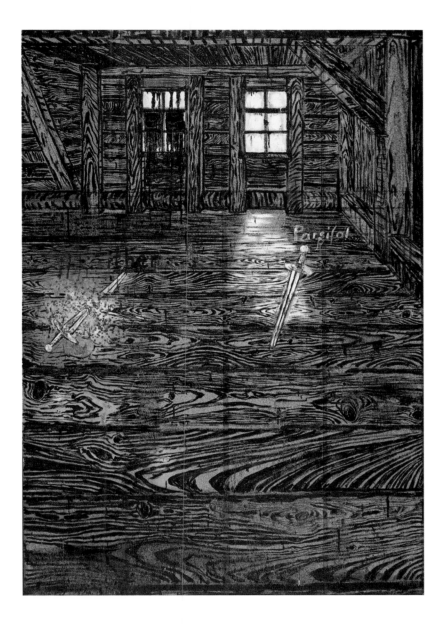

3 Parsifal III, I, IV, 1973
Oil, partially blood (I, IV) and paper fitted in on paper on canvas (triptych)
III: 332 x 228 cm, I: 307 x 435.5 cm, IV: 327.6 x 227 cm

1 Die Tür, 1973 *The Door*
Charcoal, oil and hare's fur on burlap, 300 x 220 cm

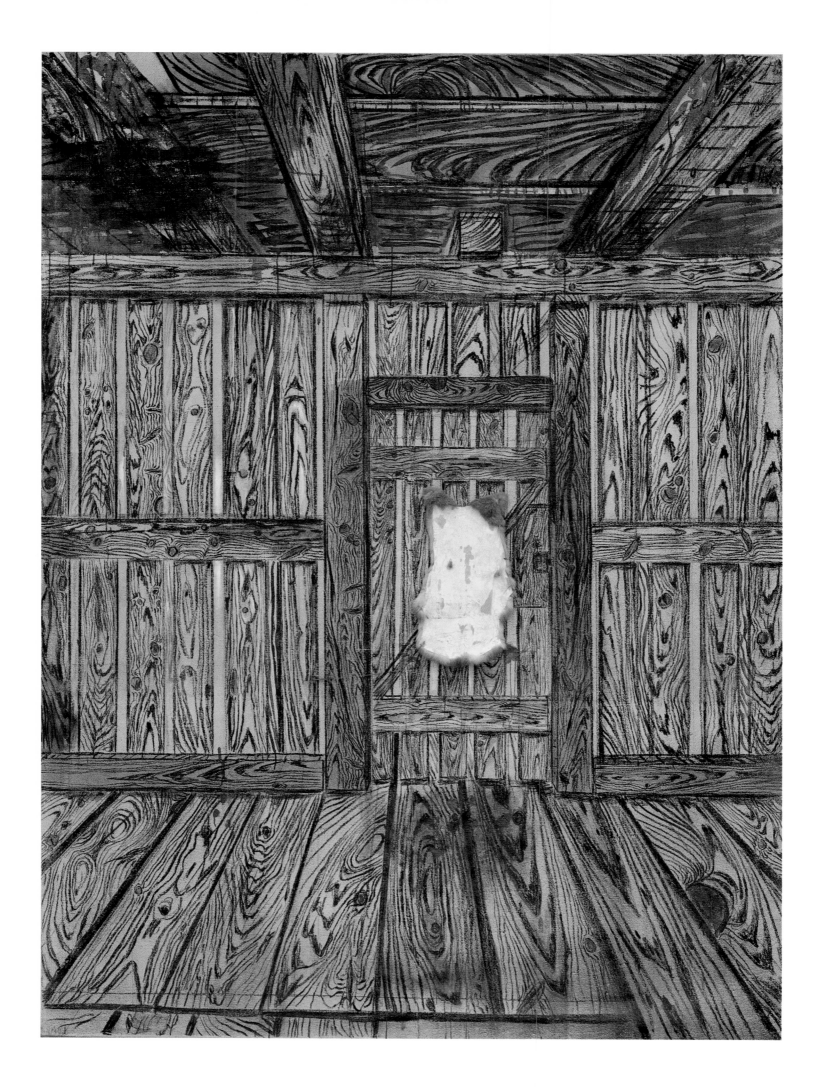

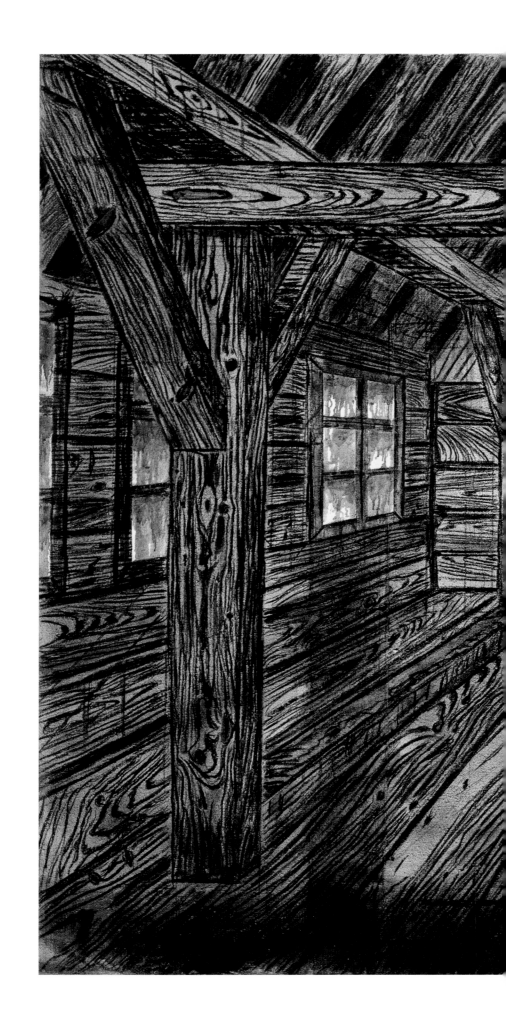

2 Notung, 1973 *Nothung*
Chalk, oil and paper fitted in on canvas, 300 x 432 cm

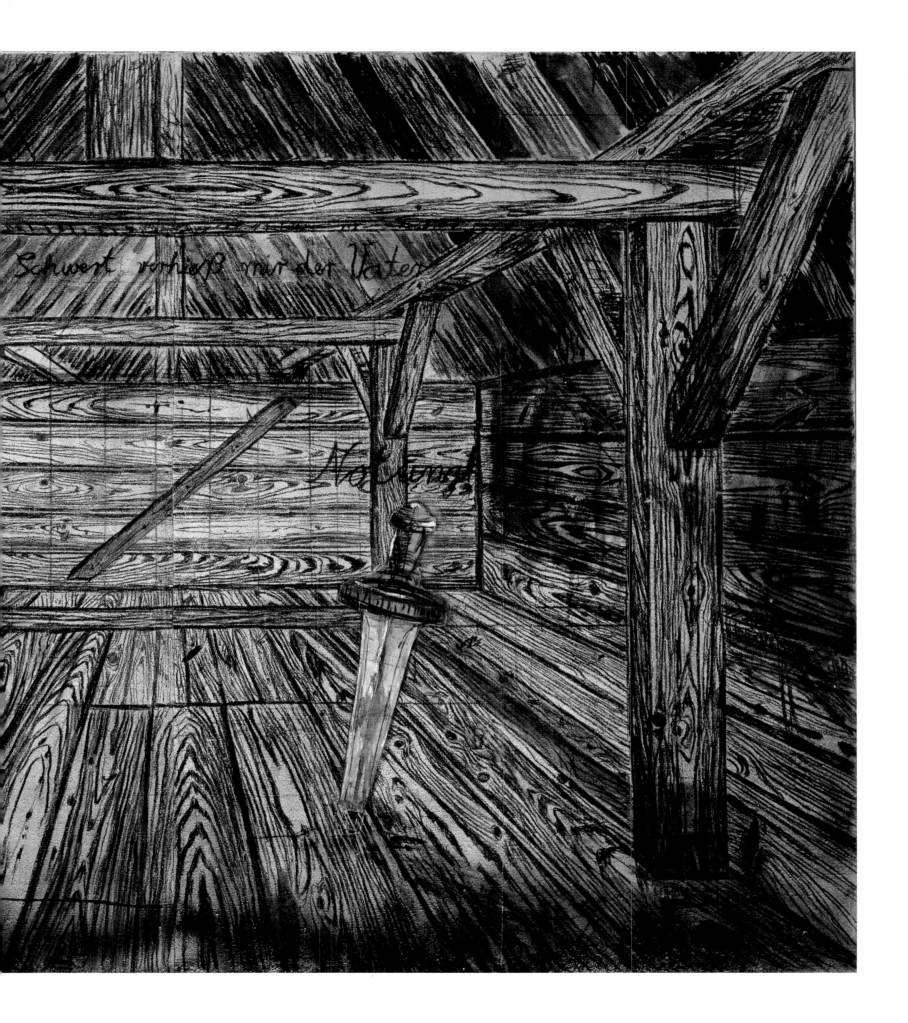

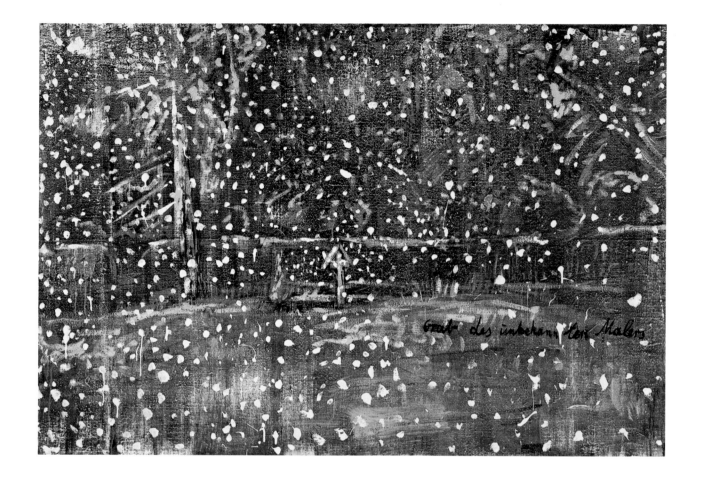

5 Grab des unbekannten Malers, 1974 *Tomb of the Unknown Painter*
Oil, emulsion and synthetic resin on burlap, 115 x 161 cm

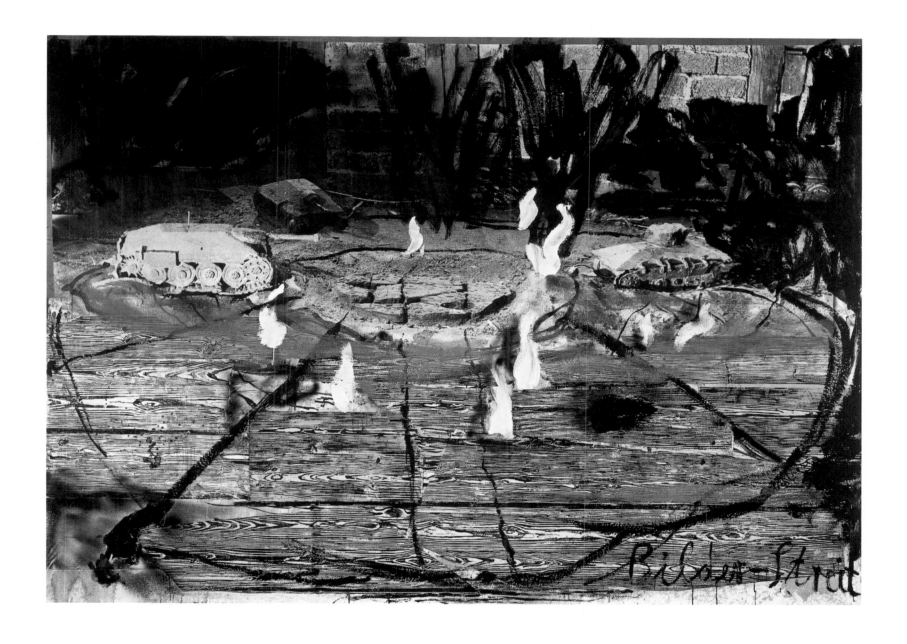

6 Bilder-Streit, 1980 *Iconoclastic Controversy*
Oil, sand, woodcut and photograph on burlap, 290 x 400 cm

II Stone Halls 1983

Mark Rosenthal

"There's tragedy in every brushstroke."[1] This acute observation on Anselm Kiefer's painting is reinforced by the fact that the theme of virtually every one of his works is concerned with mourning—mourning Jews, women of the French Revolution, heroes, misused historical figures, Germany, nature, and artists. Melancholy and elegy fill the air, indeed, these are Kiefer's principal leitmotifs and inform an understanding of his work. But Kiefer's examination of grieving is oblique; he seeks metaphors for his profound sense of loss and for the ways this emotion is enacted. In particular, architectural monuments play a powerful role in his pictorial world.

Kiefer's Attic series of paintings of the early 1970s introduced the important role of architecture to his art. The wooden buildings in that series were shown to be highly flammable, if not already in flames or having suffered from fire (cat. 8, p. 40). But with the early 1980s work, great stone edifices became his focus; though less subject to the effects of fire, nevertheless, instead of strength, ruination fills these images. Bombs were needed to destroy these buildings!

The theme of the memorial to an unknown painter is a particularly evocative one in Kiefer's art because art itself is such a powerful force to him. Following in the footsteps of his mentor Joseph Beuys, Kiefer believes that art is a vehicle by which to have a dialogue with history. An artist can enact a coming-to-terms with the worst transgressions of the past. For example, throughout his work Kiefer depicts art having power vis-à-vis the scorched earth of Germany. Art can be a weapon, too, by which the artist combats, corrects, and critiques historical terrors, as when he depicts a palette doing battle with tanks in a number of works, particularly those on the subject of the Iconoclastic Controversy (see cat. 6, p. 49). Kiefer is fascinated by this episode of the Byzantine period, during which the power of art to represent the deity frightened the clergy. Threatened, the Church would punish artists for exerting their powers of representation. The National Socialists repeated this persecution, demonizing modern artists for their subject matter. Kiefer's conceptual identification with such events became tangible when he was violently attacked by German critics at the time of his 1980 Venice Biennale exhibition. (It must be added that Kiefer's faith in the power of art is theoretical, and often pessimistic, witness the leaden wings which, like Icarus', weigh down his many sculptural palettes.)

The very title *Tomb of the Unknown Painter* is an example of Kiefer's artistic power used to undo and correct history. In contrast to the prototypical memorial devoted to an unknown soldier, he depicts a replacement memorial, dedicated to an artist; in other words, Kiefer proposes a new society and order of heroes, with the artist and art at its pinnacle. Here is an instance of transforming swords into plowshares.

In the 1983 rendition of this theme (*To the Unknown Painter*; cat. 10, pp. 56–57) Kiefer places a palette—symbol of the artist—on a stick, much as decapitated heads were stuck in the ground during the Russian and French Revolutions. Kiefer had depicted palettes during the 1970s in ramshackle cellars, but the architectural context elevates the symbol of the noble activity of art. With a beautifully mysterious sky completing this dramatic scene, the palette connects the earthly and heavenly realms.

The ceremonial sense of the scene is enhanced by the square columns that are characteristic of Nazi adaptations of ancient architecture, indeed, the setting recalls the outdoor courtyard for Hitler's Chancellery designed by Albert Speer. It is typical of Kiefer's reordering of history that his rendering in no sense duplicates the assured stability of the Nazi buildings, for the architecture seems to have gone through some sort of burning process, only to be reconstituted in this

newly arrived memorial. It is always the case in Kiefer's iconography that fire may have a purifying or purging effect, hence the Chancellery has become something else. But the discrepancy between the strength of the stone and its fragile appearance is emblematic of how ambiguously Kiefer tends to mourn: in each elegy there is an uncomfortable sense that the object of mourning has been debased by the pretentious act of building a monument.

Another version of *Tomb of the Unknown Painter* (cat. 11, p. 54) was also derived, more specifically, from a Nazi source, namely Wilhelm Kreis' design for "Soldiers' Memorial". The fortress ostensibly holding the remains of the artist, and soldier before, is seen at a great distance. Although not specifically dedicated to an anonymous artist, *The Stairs* (1982/83; cat. 9, p. 55), by its title and subject, echoes many of Kiefer's works in which stairs lead to an artist's studio/sanctuary.

The National Socialist architects, in particular Speer and Kreis, made a practice of recycling ancient architectural styles for their purposes. Just as they were hardly the first to dignify their cultures by appropriating the celebrated styles of earlier societies, Kiefer adopted the process in *Shulamite* (cat. 13, pp. 60–61). Borrowing Kreis' design of a Funeral Hall for the Great German Soldiers in the Hall of Soldiers, Berlin, 1938, for the purpose of memorializing a mythic Jewish heroine, Kiefer put a new twist on the technique, and effectively "corrected" the Nazis' sentiment. One of Kiefer's most poignant series, Margarete and Shulamite, was based on a poem written in 1945 and published in 1952 by Paul Celan, a victim of the concentration camps who survived but later committed suicide. Celan's poem entitled "Todesfuge" (Death Fugue; see p. 62) describes two women, Margarete and Shulamite: the former epitomizes blond, Arian womanhood, while the latter is the dark-haired, Jewish personage. After several tentative renderings, Anselm Kiefer achieved a resonant depiction of Shulamite by making a memorial in which the sense of burning and smoke that fills the subterranean space assumes macabre references to the death camps where Celan's heroine would have lived and died. But Shulamite is given an eternal life by Kiefer, who turns Kreis' building over to her.

Kiefer's is a new civilization built on an earlier one, much as in alchemy, a subject of considerable interest to him, blackened earth might be transformed into gold. Through the vehicle of art and fire, Kiefer attempts a transformation, but not for the purpose of purging, which is impossible in his cosmos. He prefers to imagine a more archeological construct whereby one thing is built on top of another, with all layers remaining visible through the miasma. In this regard, it is interesting to note that Kiefer has been a great admirer of Gordon Matta-Clark,[2] the American artist who cut great sections away from various New York City structures. In doing so, he both assaulted seemingly impervious entities and ostensibly "improved" their nature. Similarly, Kiefer takes nothing for granted, reassigning the dedication of memorial structures to new heroes. Although his world is often dilapidated and degraded, Kiefer's reuses of architecture represent a hopeful sign. As the largest physical embodiments of civilization, buildings are powerful symbols and memento mori.

When Kiefer produced these paintings, on the heels of his explicitly World War II subjects of the 1970s, the outcry was considerable, particularly in Germany. The attacks at the time of the Venice Biennale, 1980, continued and reached a hysterical pitch during the run of the American retrospective of his work in 1987 through 1989. The most common theme was that Kiefer, instead of critically undermining the Nazi past, was in fact luxuriating in it, simply by dealing with the subjects and images of that time. In this view, Kiefer's stone buildings were interpreted as expressions of his melancholy for the faded grandeur of the National Socialist period, notwithstanding the new deities that he celebrated with the titles. However much Kiefer disagreed with this psychological interpretation, the German critics asserted this explanation of his subconscious intentions. Indeed, they ridiculed as naïve the American public, and especially the Jewish collectors who so passionately acquired Kiefer's art.

Not surprisingly, much has changed since those days. To begin with, Kiefer has found a much more sympathetic audience among Germans, at least on the part of collectors and curators, even as he himself moved from Germany to France. One might even

speculate that this embrace of Kiefer in his native land is due in large part to his canonization in the United States. Nevertheless, at the time of his Berlin retrospective in 1991, the critics went on a rampage yet again. Whether the imagery of the Stone Halls has lost any of its shock value is a question better answered in Germany than in the United States, for Americans remain quite interested in the theme. However, Kiefer, himself, appears less inclined to further mine German subjects; instead, his attention has turned to other periods of history.

1 This observation was made to me by Ann Hanson in 1988.
2 Told to the author in 1986.

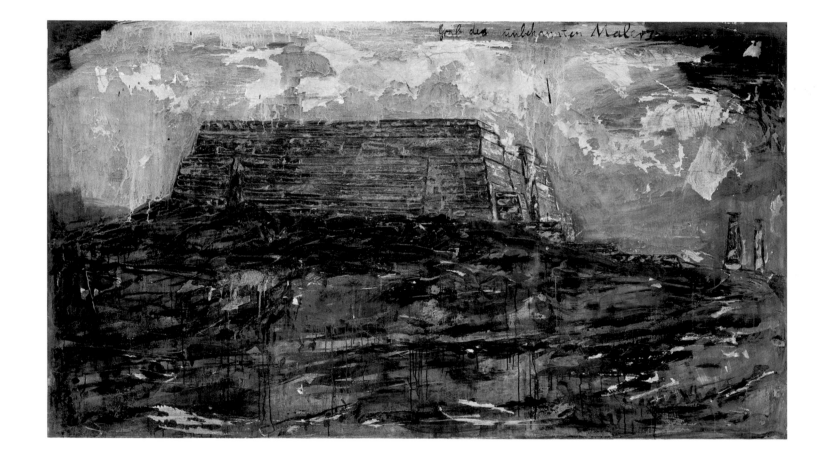

11 Grab des unbekannten Malers, 1983 *Tomb of the Unknown Painter*
Oil, emulsion, shellac, latex and straw on canvas,
133 x 229 cm

9 Die Treppe, 1982/83 *The Stairs*
Emulsion, shellac, straw and traces of fire on photograph
on canvas, 330 x 185 cm

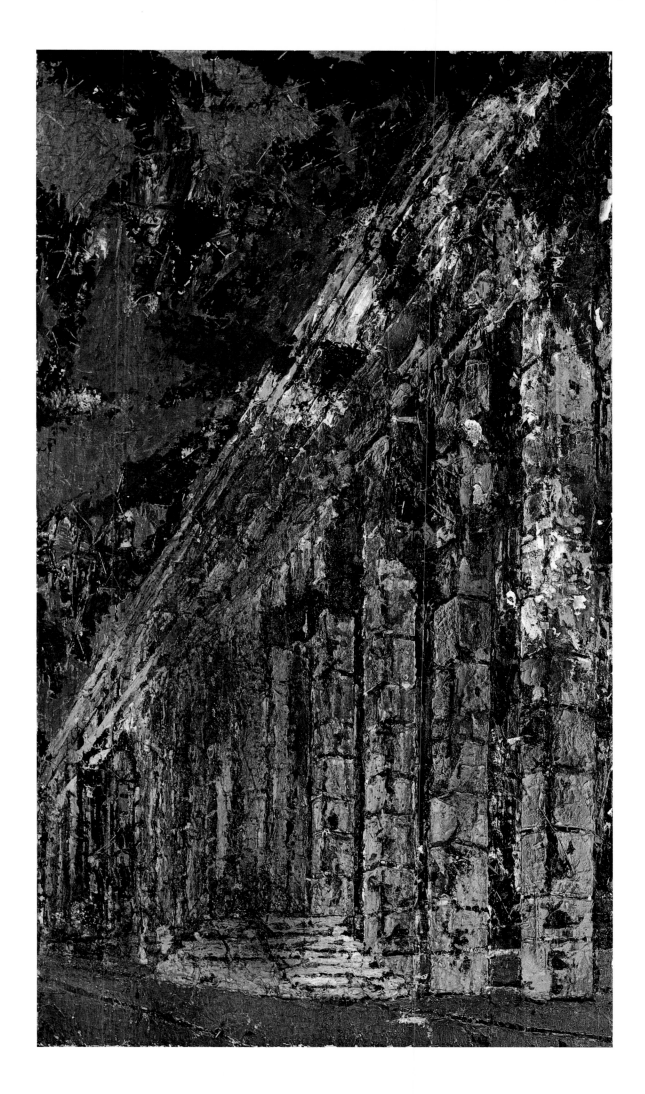

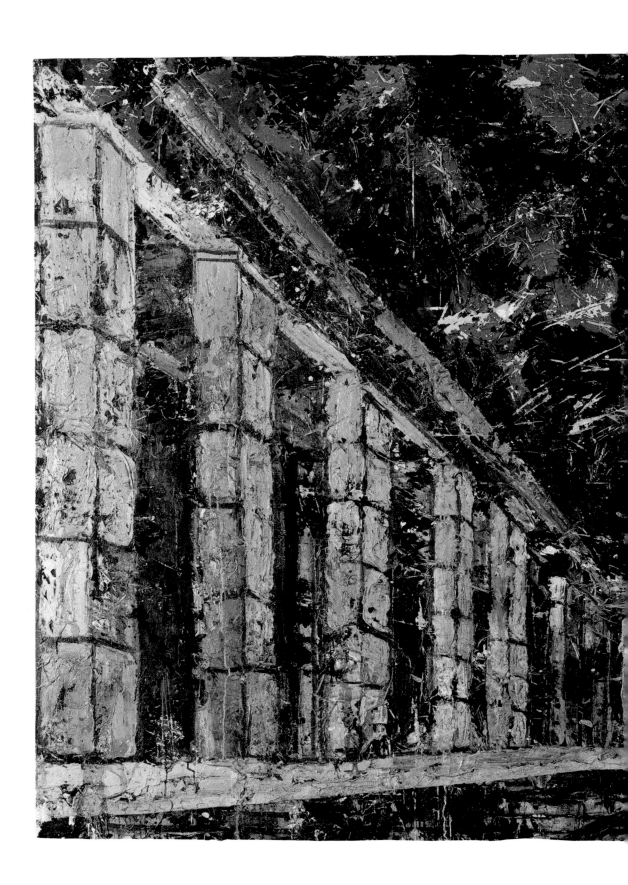

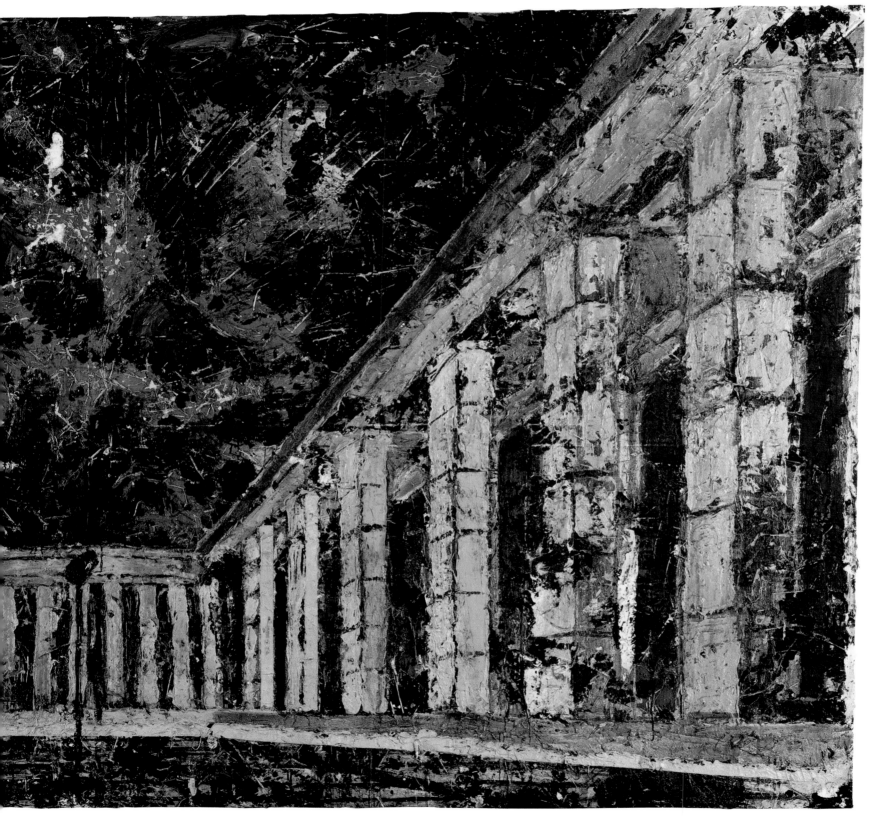

10 Dem unbekannten Maler, 1983 *To the Unknown Painter*
Oil, acrylic, emulsion, shellac and straw on canvas, 208 x 381 cm

I think in vertical terms, and Fascism was one of the levels.
But, I see all the layers. In my paintings, I tell stories
in order to show what lies behind history. I make a hole
and pass through.

Anselm Kiefer

12 Untitled, 1983
Emulsion, oil, shellac, woodcut, synthetic resin and straw on canvas, 260 x 190 cm

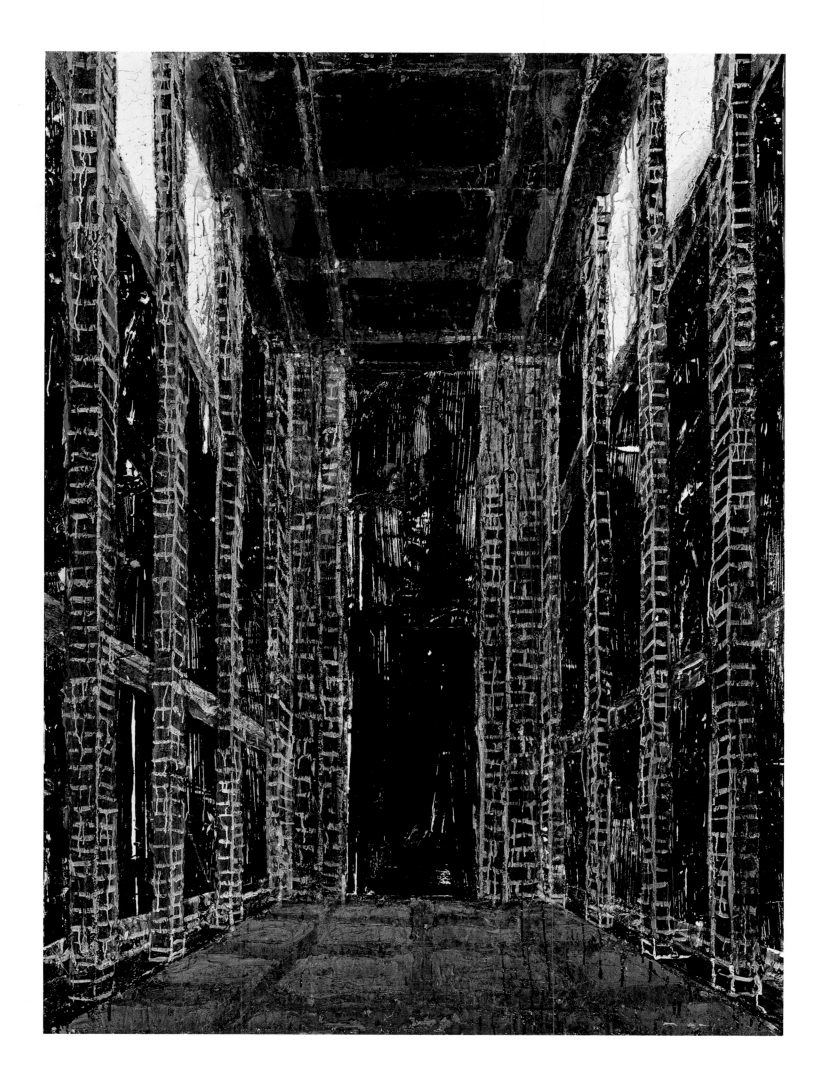

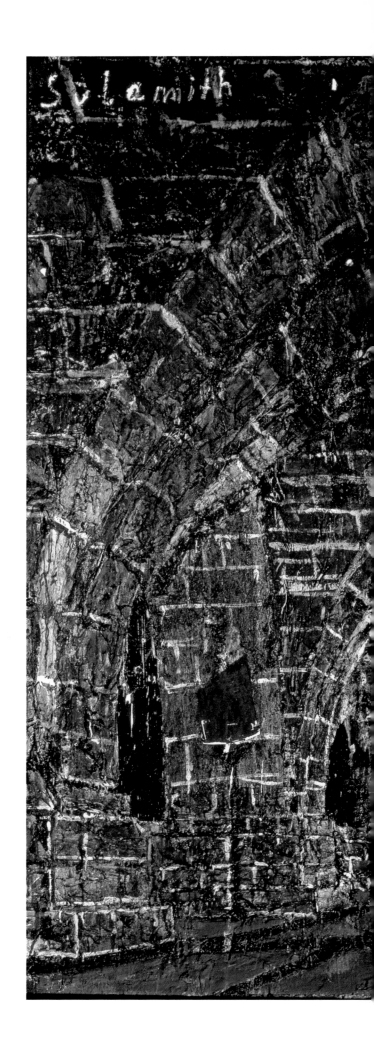

13 Sulamith, 1983 *Shulamite*
Oil, emulsion, shellac, acrylic, straw and woodcut on canvas, 290 x 370 cm

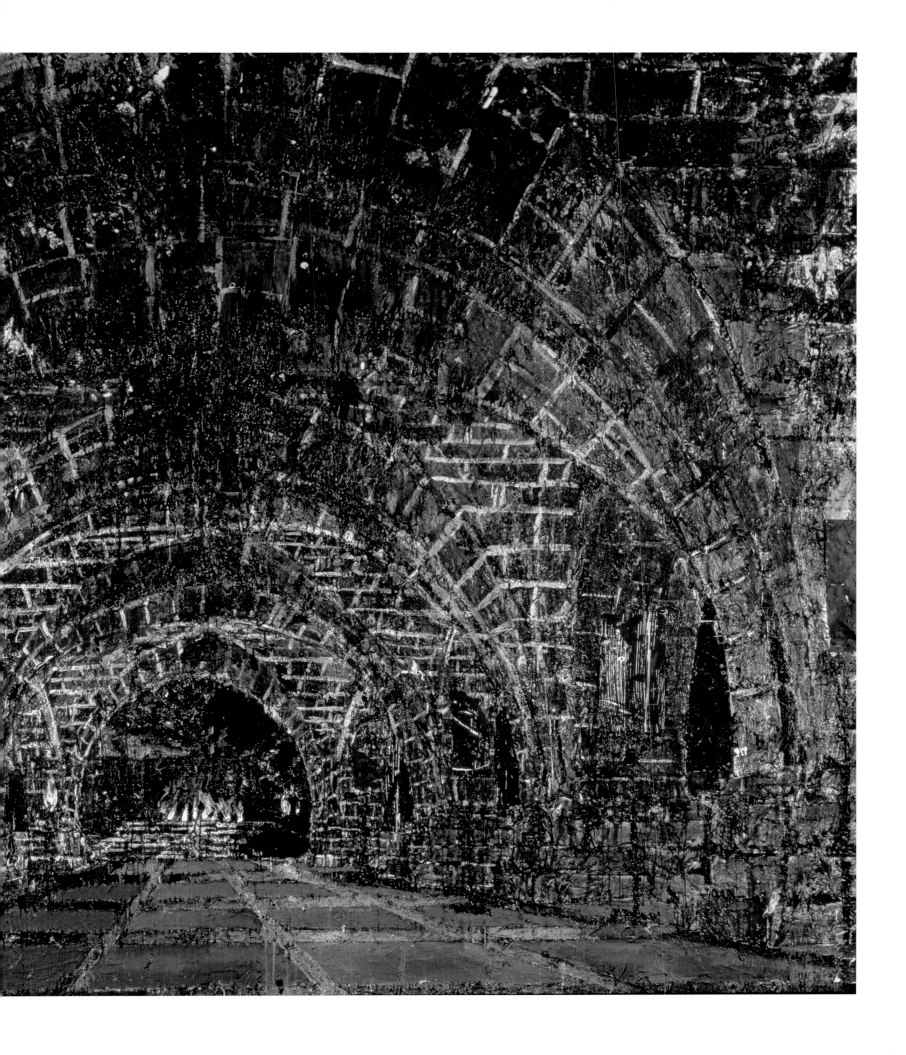

Paul Celan *Death Fugue*

Black milk of daybreak we drink it at sundown
we drink it at noon in the morning we drink it at night
we drink and we drink it
we dig a grave in the breezes there one lies unconfined
A man lives in the house he plays with the serpents he writes
he writes when dusk falls to Germany your golden hair
 Margarete
he writes it and steps out of doors and the stars are flashing
 he whistles his pack out
he whistles his Jews out in earth has them dig for a grave
he commands us strike up for the dance

Black milk of daybreak we drink you at night
we drink in the morning at noon we drink you at sundown
we drink and we drink you
A man lives in the house he plays with the serpents he writes
he writes when dusk falls to Germany your golden hair
 Margarete
your ashen hair Shulamith we dig a grave in the breezes
 there one lies unconfined.

He calls out jab deeper into the earth you lot you others sing
 now and play
he grabs at the iron in his belt he waves it his eyes are blue
jab deeper you lot with your spades you others play on for
 the dance

Black milk of daybreak we drink you at night
we drink you at noon in the morning we drink you at sundown
we drink you and we drink you
a man lives in the house your golden hair Margarete
your ashen hair Shulamith he plays with the serpents

He calls out more sweetly play death death is a master from
 Germany
he calls out more darkly now stroke your strings then as smoke
 you will rise into air
then a grave you will have in the clouds there one lies
 unconfined

Black milk of daybreak we drink you at night
we drink you at noon death is a master from Germany
we drink you at sundown and in the morning we drink and
 we drink you
death is a master from Germany his eyes are blue
he strikes you with leaden bullets his aim is true
a man lives in the house your golden hair Margarete
he sets his pack on to us he grants us a grave in the air
he plays with the serpents and daydreams death is a master
 from Germany
your golden hair Margarete
your ashen hair Shulamith

Ingeborg Bachmann *The Game is Over*

My dearest brother, when will we build a raft
and sail down through the sky?
My dearest brother, the weight's too much for our craft
and we will sink and die.

My dearest brother, we sketch out on paper
countries and railway lines.
Watch out, close to the set of tracks right here
you'll be blown high by mines.

My dearest brother, to a stake I want to be tied,
raising then a cry.
But out of the valley of death you choose to ride,
and off together we fly.

Awake in the gypsy camp and the desert tent,
the sand runs out of our hair;
your age, my age, and the age of the planet
in years can have no measure.

Don't be fooled by the spider, the clever raven,
or in a bush, the feather;
however, don't eat and drink inside a fool's haven,
lies foam in skillets and pitchers.

On the golden bridge, only he who might know
the troll's secret word can win.
I'm sorry to say, along with our last snow,
it melted in the garden.

From many stones our feet are sore. One can heal.
Let's hop to the fairy tale king,
for it's in his mouth that the castle key's sealed,
and he'll lead us away to sing:

It is a happy time when the date pit sprouts!
Everyone who falls has wings.
Red foxglove is what hems the poor's shrouds,
and your bud is sealed in my ring.

We must go to sleep, my dearest, the game is over.
Off on tiptoe. Our nightshirts billowing white.
The house is always haunted, say Father and Mother,
when we exchange breaths at night.

für Ingeborg Bachmann

III Archaic Architectures 1997

(Pyramids and Desert Clay Architecture)

Katharina Schmidt

The pyramid (cat. 15, pp. 68–69) dominates the vast horizontal oblong format. A massive triangle, bare and rough, it thrusts upward to the full width of our view. Lofty and remote, the apex looms against an overcast sky. A minor displacement of the angle of view, a slight deviation from axial symmetry, endows this crude presence with a massive dynamism and conveys an impression of three dimensions, despite the simple geometric articulation of the picture surface. The sky is sandy, oppressive and remote; the horizon, largely concealed by the structure, is almost invisible. Akhet Khufru was the name given by the founder to this monument, and to the city and palace that accompanied it: Horizon of Cheops. The narrow, vertical notch in the masonry halfway up reveals that this is a view of the south side.

In the cycles of work in which he explores the contemporary resonances of complex themes from myth, history and art, Anselm Kiefer has often depicted architectural forms: massive interiors with interlocking wall patterns from which there is no escape. In reinterpreting derelict structures that have lost their original functions, he has succeeded to a startling degree in conveying the heedless treatment suffered by those structures, as well as their obstinate persistence. At the same time, he has stripped away many incrustations. Inscriptions indicate a change of use: tantalizing, surprising possibilities. A hopeless new start? A rational intervention? At once hermetic and charged with history, his exterior views show how the passage of time causes architecture and landscape to approximate to one another. *Grab des unbekannten Malers* (*Tomb of the Unknown Painter*, cat. 11, p. 54) is the dedicatory inscription on one such monument, which grows out of a hillside like Max Ernst's "Entire Cities".[1] Later on, Kiefer's interest in ancient civilizations shifts somewhat from their myths to their build-

ing forms. Their ruins, the vestiges of their decay and all the signs of the departure of organic life offer occasions for new *Vanitas* images nourished by contemporary experience.

Cheops[2] built himself a tomb, unprecedented both in its constructional technique and in its size, on a rocky outcrop in the Libyan Desert.[3] The Great Pyramid attracted interest from an early date; its destruction also started early. The Greeks ranked it first among the Seven Wonders of the World; but, by the time the writers of antiquity described it, the glittering pyramidion at its apex and part of the apex itself were missing. The white limestone casing had also gone. Only in the Enlightenment did a growing spirit of scientific enquiry lead to the systematic investigation of the monument. To this day, researchers are still exploring its idiosyncrasies and enigmas. The narrow opening halfway up one side was caused by irresponsible excavation of the interior. In Kiefer's painting, the crude break in the skin serves as a reference to the core of the architecture, and thus to its original function.

Kiefer's majestic view, in which the stone surface appears as a rough, sculptural relief, and the clouds in broad, horizontal swathes, would surely have taken its place among the nostalgic products of Egyptomania and Orientalism, had we not eventually discovered its inscriptions. "dein und mein Alter und das Alter der Welt" ("your age and my age and the age of the world"), is written in the sky at top right; below, in blurred and weathered letters among the stone blocks of the base, is the dedication: "für Ingeborg Bachmann".

From an early stage in his career, Kiefer began to integrate handwritten inscriptions—mostly cursive, and his own—into his compositions. This enabled him to hold a discreet balance between illusionistic spatial

effect and the two-dimensional surface, and at the same time to displace a part of the painting's effect from visual perception to reflection. This opens up additional layers of meaning. By using the obsolete formula of dedication as a visual device, Kiefer retrieves a distinctive level of significance. Ranging from subtle allusion to plain identification, his dedications are as varied in character as the dedicatees.[4] Dedications are a weapon against oblivion; they contribute to the history of influences, and enable the artist to share his isolation with another person. Kiefer has recently spoken of the close affinity that he feels for the Austrian poet Ingeborg Bachmann, and he quotes her in several of his works.[5] The line of hers that he includes in this painting,[6] written in the clouds as if about to blow away across the desert, relates the individual human life to cosmic time.

In this poem, the authorial self speaks to a brother: a dialogue that translates, in painting, into the painter-viewer relationship—or is the artist addressing the pyramid?[7] What is certain is that his links with Bachmann's work extend beyond individual lines or poems. For, in the "Desert Chapter" of her novel *Das Buch Franza*, a woman in extreme distress of mind gives herself a mortal wound at the base of this same pyramid, "at this tomb".[8] The novel forms part of an ambitiously conceived "Varieties of Death Project",[9] which Bachmann intended as a tribute to the victims, the defenceless ones, those for whose sufferings no law exists. Kiefer inscribes Bachmann's name on the greatest architectural work of humanity, and rededicates the empty tomb to her memory and in her spirit.

The Desert Paintings are more tranquil in composition, light and clayey in colour, and—except for those that are bound into books—vast in extent. Some of these works, too, are dedicated to Bachmann, a writer for whom the desert possessed existential significance both as a metaphor and—later—as a personal experience.[10]

Skimming across the arid wastes to the distant horizon, the eye is arrested by a line of poetry: "wach im Zigeunerlager und wach im Wüstenzelt, es rinnt uns der Sand aus den Haaren"[11] ("Awake in the gypsy camp and awake in the desert tent, the sand trickles out of our hair"; cat. 18, pp. 72–73). The sentence is shared between the two halves of the painting: like a

fence, it marks off the earth from the barely visible sky. Endless, stony and cracked, the ground is stratified, weathered and powdered with windborne desert sand. In the centre of the rectangle, surprisingly, vestiges appear. Clay bricks, mould-made by hand—just as they were thousands of years ago—and laid with care.[12] A strip, of twelve rows and more, recedes from the left towards the centre. There, the direction changes; a new strip makes a right-angled join, continues rightward, and meets the edge of the image. The perspectival arrangement of this large-scale figure, with its smaller internal drawing, causes the pictorial space to appear even deeper. The rough, bare ground in the foreground forms a wedge that positively draws us in. On this vacant area, as a diametrical contrast to the rigid geometric pattern of the bricks, something lies in a confused tangle. To the left and beyond, on the building materials, there are striations that look like cracks: thorns, wire, barbed wire.

This hint shockingly ties in with the line of poetry. Where the painting seemed a moment ago to lead into the wilderness—or was it the place of trial, an area to be traversed, perhaps some rough cradle of humanity?—there is now a sense of oppression and unease, a sense of lurking life. Gypsy: the word stands for the Romantic ideal of a free life outside society and its constraints! Artists identified with gypsies; their songs appealed to wishful fantasies; clichés and illusions attached like burrs to their itinerant lives. But now their camp can never again be a home, a transient place to sleep close to the earth. The word has been stolen. It now belongs to destruction and terror. The word "camp" stands for fear. In the camp, better stay awake; in the camp, sleep is snatched away. Life trickles away, as sand runs out of your hair.

Once more, Kiefer creates a superimposition of ancient, mythic images, archaic vestiges and new, historical experience; but now he leads us into different climatic zones. The grief seems quieter, the language more indirect. Here, the harmony with Ingeborg Bachmann's poem, and with her essential theme, appears perfect.

The archaeological terrain of another desert scene is less sparse (cat. 16, pp. 70–71). Brick construction, and the shape of a building whose upper part has been largely demolished, suggest an ancient Oriental ruin.

The ruin itself, set back a little way, built in regular courses and with a surface of hermetic uniformity except for the two narrow entrances, is a monumental, dominant presence. It is seen in perspectival recession from near right to far left. Part of the adjacent façade is visible on the right, with remains of buttresses. Above the crumbling debris, and close to the edge of the picture, we read the neatly written dedication, "für Ingeborg Bachmann". At bottom right, the line "der Sand aus den Urnen" ("the sand from the urns") runs along the ruts of a passing road. In this case, the dedicatee and the author of the quotation are not identical. The quotation reproduces the title of a book of poems by Paul Celan, published in Vienna in 1948.[13] It was there that Bachmann met Celan.[14] Kiefer's painting unites two revered and closely related artists, both of whom died tragically, in a kind of memorial image. The quotation makes it clear that a number of levels of meaning coincide. The ruin motif, the traditional symbol of death and transience, is revived in a new variant: stripped of vegetation, desiccated, a radical image of desolation, of total absence. At the same time, other, oppressive associations enter our minds. The interlocking grid structures of bonded brickwork, which cover the painting, are weirdly reminiscent of later sites of destruction.[15] Their rigid pattern, the sign of the ineluctable, disappears only in a few places, beneath smears of clay and sand—a muted metamorphosis. Celan's verbal image is one of elemental power, which goes beyond consolation. Just as clay bricks were used for the earliest organized settlements, urn burial is an immensely ancient funerary practice. Both the building technique and the ritual are still in use today. The urns, as vessels, symbolize the human body and—another *Vanitas* motif—also its fragility and impermanence, since they contain the mortal part of it. In Celan's poem the sand, which is crumbled stone, has left no traces of it behind. Nothing has endured. Nothing will endure. Only art remains to remind us of oblivion.

1 See, among other works, Max Ernst, *La Ville entière* (*The Entire City*), 1935–36, Kunsthaus Zürich.
2 Cheops is the Greek form of the name of Khufru (a member of the Fourth Dynasty, *c.* 2575–2465 BC), who reigned for approximately thirty-five years.
3 The uniqueness of the pyramid lies in the perfection of its form, the technical accomplishment of its construction, and its emblematic value as the reflection of a self-contained world-view.
4 Compare the importance of dedications in the work of Cy Twombly.
5 Heinz Peter Schwerfel, "Interview mit Anselm Kiefer", *art* 7 (2001), pp. 23, 25: "We would not recognize a poem by Ingeborg Bachmann as perfect, were it not for the mediocrity and absurdity of the world." Bachmann's poems "are founded on despair at an absurd world". "With Ingeborg Bachmann, the tissue of references has become so strong that in my paintings I believe that I am conducting a correspondence with her."
6 Ingeborg Bachmann, "Das Spiel ist aus", in Bachmann, *Anrufung des Großen Bären*, fourth stanza. See p. 63.
7 Cf. also Anselm Kiefer, *Homme sous une pyramide* (1996), 354 x 500 cm.
8 Ingeborg Bachmann, *Das Buch Franza*, Munich and Zürich 1998, p. 134. This is a separately published volume of *Das Todesarten-Projekt*.
9 For a synopsis of its genesis, see Bachmann (as note 8), p. 263.
10 "I am again often thinking of the desert, of the moment when laughter returned to me." Ingeborg Bachmann, quoted by Adolf Opel, *Ingeborg Bachmann in Ägypten*, Vienna 1996, p. 188.
11 See note 6.
12 While in India, Kiefer photographed the making of clay bricks by a technique still in use today. Many of these impressions found their way into his Desert Pictures (*Wüstenbilder*) and Desert Books (*Wüstenbücher*). At Höpfingen, in the Odenwald, from 1988 until the early 1990s, he owned a former brickworks, which he used as a studio, and from which he derived a wealth of imagery. "The attraction of this industrial architecture, for him, probably consisted in the monumental scale of the buildings, the associations with the crematoria of the concentration camps of National Socialism, the ruinous state of the site, and the tangible presence of the elements used in making bricks: earth, water, air and fire." Ute Fahrbach-Dreher, "Höpfingen wird Gesamtkunstwerk", *Denkmalpflege in Baden-Württemberg* 2, vol. 27 (1998), p. 84.
13 It is also the title of one of the individual poems. In addition to this cycle, Celan included in the same volume the poem "Todesfuge", to which Kiefer responded with important groups of work based on the lines "dein goldenes Haar Margarete/dein aschenes Haar Sulamith" ("your golden hair Margarete/your ashen hair Shulamith"). The poems in this volume, which Celan was to republish in his later collection *Mohn und Gedächtnis* (1952), also included "Der Sand aus den Urnen". Twenty-two poems from the original set are directly addressed to Ingeborg Bachmann in the second person (marked as such by Celan himself, MS, Literaturarchiv Marbach). Paul Celan (Paul Antschel, Czernowitz 1920 – Paris 1970) was the most important lyric poet writing in German in the twentieth century. He lost both of his parents in concentration camps in 1942–43. Irrevocably marked by the horrors of the Holocaust, he ended his own life by drowning in the Seine.
14 On 20 January 1948.
15 Cf. Anselm Kiefer's group of works under the overall title of Stone Halls. The traumatic experiences endured by Max Ernst and Hans Bellmer in the internment camp at Les Milles in the South of France found expression in works that incorporate similar brickwork patterns.

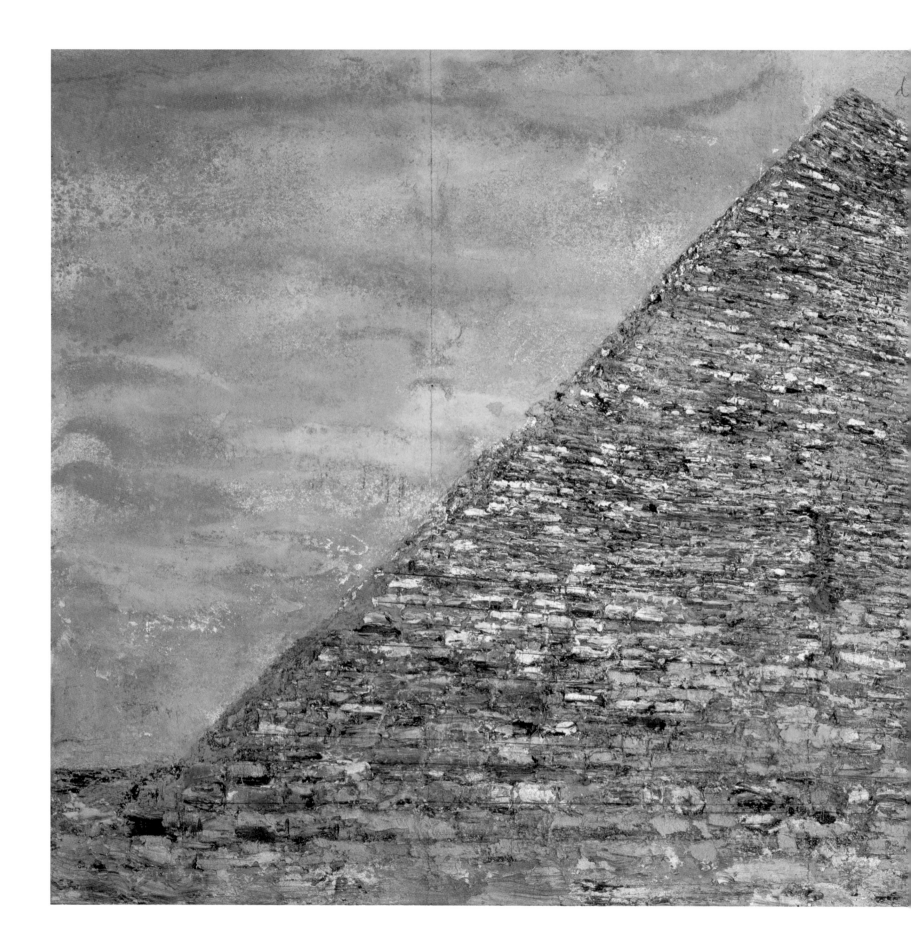

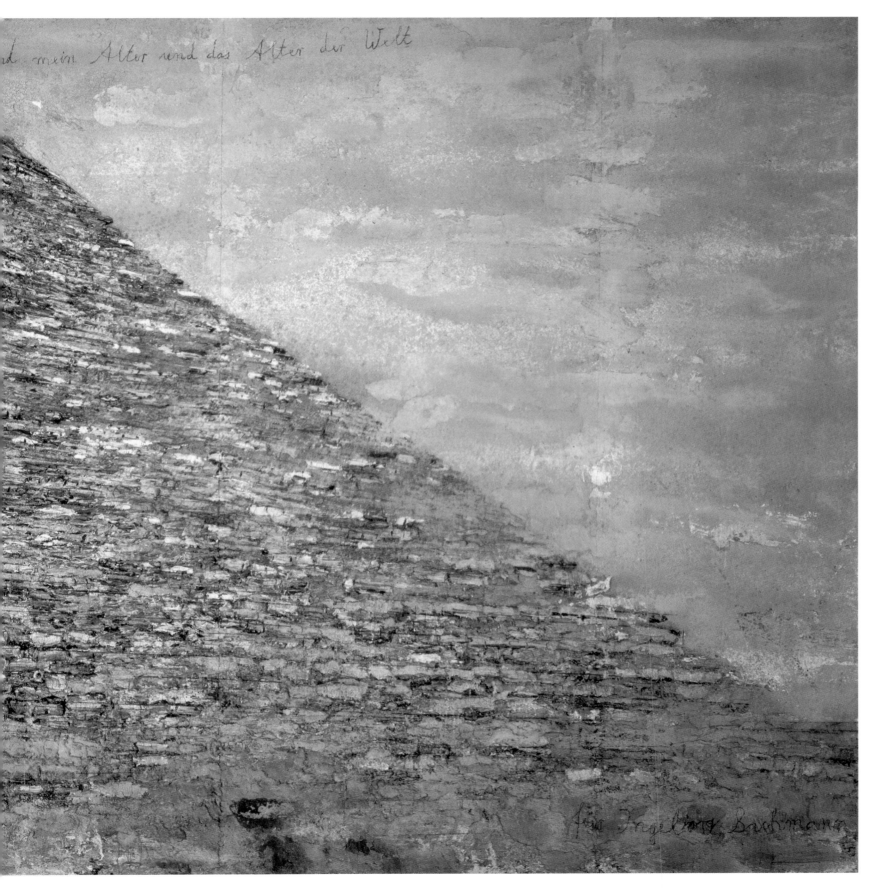

15 Dein und mein Alter und das Alter der Welt, 1997 *Your Age and My Age and the Age of the World*
Oil, emulsion, shellac, ash and applied terra-cotta on canvas, 470 x 900 cm

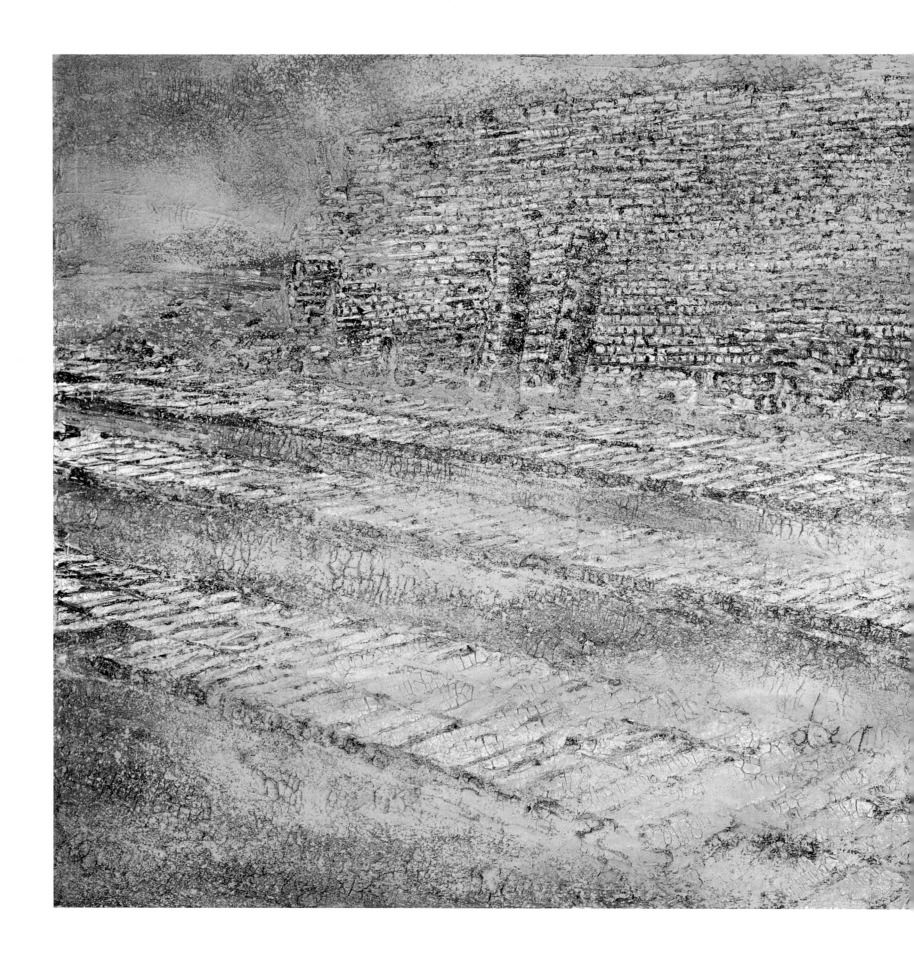

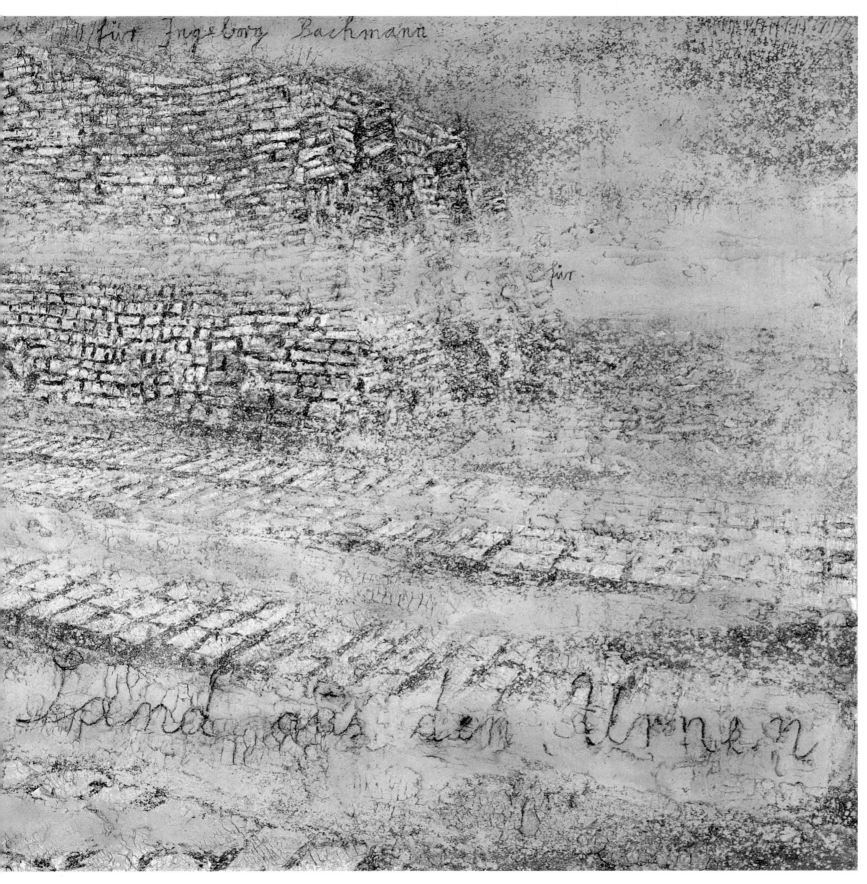

16 Der Sand aus den Urnen, 1997 *The Sand from the Urns*
Emulsion, acrylic, shellac, clay and sand on canvas, 280 x 560 cm

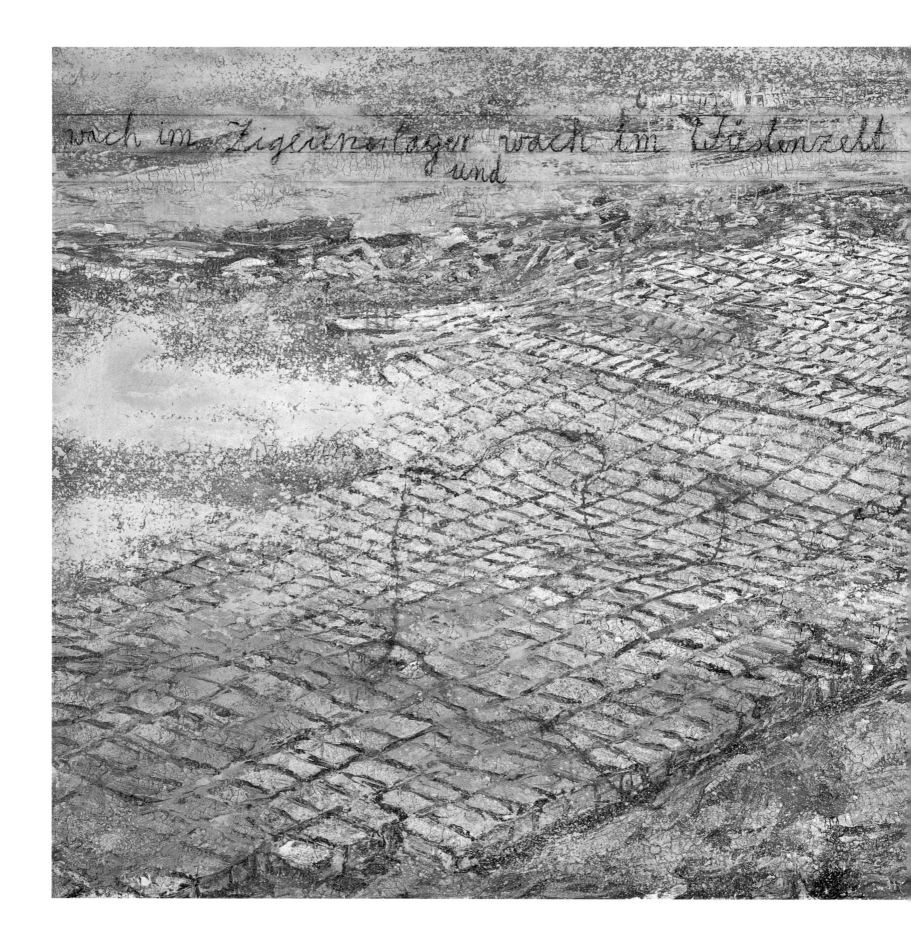

wach im Zigeunerlager wach im Wüstenzelt
und

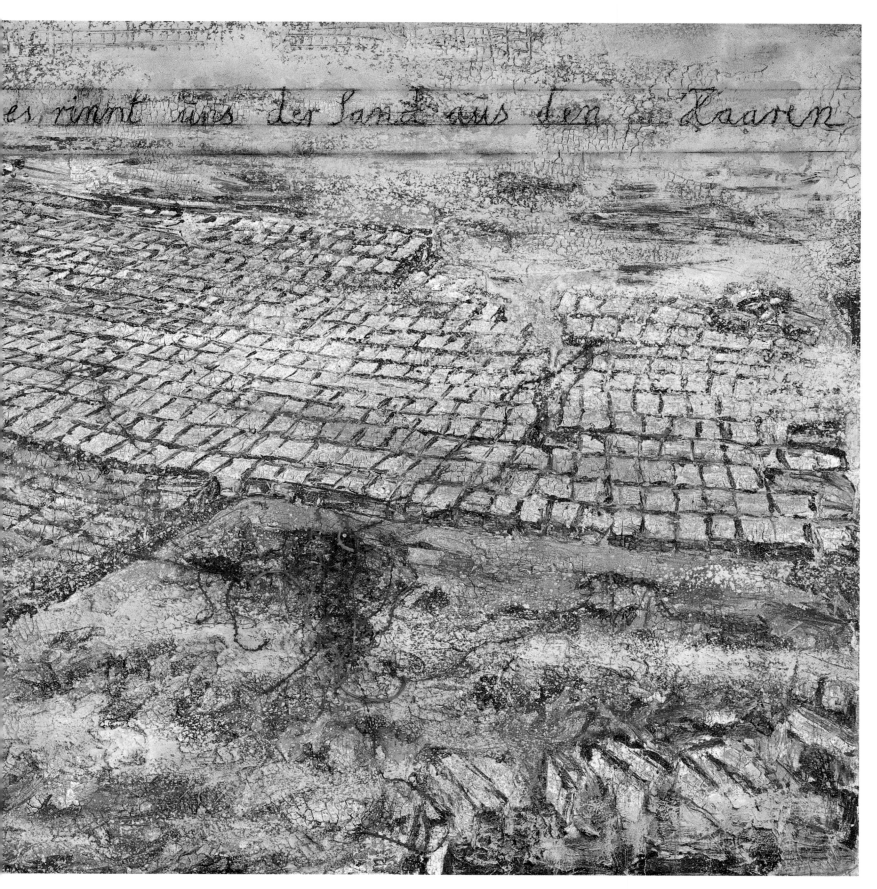

18 Wach im Zigeunerlager und wach im Wüstenzelt, es rinnt uns der Sand aus den Haaren, 1997
Awake in the Gypsy Camp and Awake in the Desert Tent, the Sand Trickles out of our Hair
Emulsion, acrylic, shellac, burnt clay, sand and iron on canvas, 280 x 560 cm

IV Cosmos and Star Paintings 1995–2001

Katharina Schmidt

In the Cosmos and Star Paintings, unlike the earthbound desert landscapes, the eye once more turns aloft. No longer suppressed, the sky expands in pictorial space, prompting an age-old question that is also new. In art as elsewhere, since the mid twentieth century, the development of astronomy and space research and the resulting sensational images of the cosmos have endowed the starry sky with an urgent contemporary relevance.

In 1980, Anselm Kiefer depicted himself in a full-length self-portrait, a photograph overpainted in acrylic (cat. 7, p. 78). Backed by a starry sky, he seems to wade, bare-footed, in the words of a quotation from Immanuel Kant: "Der gestirnte Himmel über uns, das moralische Gesetz in mir" ("The starry sky above us, the moral law within me").[1] The challenging, contemporary-looking pose and the wristwatch contrast with the timelessness of the crumpled white shirt. This rather touching figure receives a consolidating emphasis from the palette drawn on the chest in black. It radiates like a star; it brings, as it were, the sky into the heart, carrying the philosopher's maxim home to the artist himself, who thus gains—or offers for discussion—a cosmic point of reference for his own work.

Since 1995, Kiefer has reverted to this cosmic theme in a major and still unconcluded cycle of work. Here, the most recent discoveries of physics appear alongside ancient mythological and astronomical traditions; astral mysticism and philosophical and theological systems blend with poetic interpretation. The dominant motif that emerges is the sunflower. In a group of works initiated in 1996, this is seen as a single head or as several, sometimes associated with the human figure and with inscribed titles such as *Sol invictus* (*Unconquered Sun*), sometimes with dedications. Quotations appear, taken from Ingeborg Bachmann, Osip Mandelstam and Robert Fludd. The sunflower never appears as an ornamental plant or—as in Van Gogh's still-lifes—a bouquet. In its cultivated form, this plant originated in the southern part of North America in pre-Columbian times; it reached Europe in the sixteenth century, via Peru and Spain. Its large, inclined, composite flower-head, with a crown of brilliant yellow corollas surrounding a disc of blackish miniature flowers, the whole mounted on a stalk up to five metres high, gave it the name of *Helianthus*, sunflower, and predestined it to be a symbol of the heavenly dispenser of light and life.

In *Sol invictus* (cat. 14, p. 91), Kiefer shows a sunflower plant at life size; hence the tall, narrow format. He himself is seen reclining beneath it; the unclothed body is highly stylized and seems de-individualized.[2] He lies on a cloth, eyes closed, his head close to the lower edge of the painting, his hands resting on his body: dead, asleep, or in trance? Thomas McEvilley has argued that the outstretched, supine pose adopted by the figure in recent paintings by Kiefer corresponds to the position known in Hatha Yoga as *shavasana*: an exercise in the "checking of the mind" with the purpose of profound renewal.[3] The body is turned to the right and foreshortened, thus creating a sensation of space, although the background is open in all directions (the scene is marked as an exterior by the white clouds and the presence of the sunflower plant close to the head). Startlingly, the sunflower does not stand up straight but—frayed and withered and with tattered leaves hanging like ragged garments—bows its great head over the recumbent figure in an anthropomorphic gesture. Out of its black face, however, it has filled the air with its nutritious, dark seeds, and it scatters them over the human being at its foot.

The inscription "Sol invictus" suggests a metaphorical interpretation. If we read this as the name of the Roman sun god whose cult was promoted, notably, by Heliogabalus,[4] we are reminded of the darker side of sun worship, the misuse of this emblem of

power and radiance. Seen in this light, the blackness in the painting is alarming, and the black seeds that fill the air look like the visitation of a plague. Another interpretation is suggested by the dedication "für Robert Fludd"[5] that appears on a number of similar works. This English physician, mystical philosopher and Rosicrucian argued in his works, written under the influence of Paracelsus' Hermetic and Neoplatonic ideas, that a kind of mystical alchemy—which he regarded as fully equal in status to orthodox theology—could lead to understanding of the universe. Resolutely clinging to the geocentric image of the cosmos, Fludd outlined a system of exact correspondences between the macrocosm and the microcosm. Just as the sun stands at the centre of the macrocosm, the heart is central to the microcosm: "Fludd states that the origin of all things may be sought in the dark Chaos (potential unity) from which arose the Light (divine illumination or actual unity)."[6] Fludd's major theoretical statements are founded on the philosophy of the Neoplatonist, Nicholas of Cusa:[7] the principle of *coincidentia oppositorum*, whereby contraries are contained within each other, and the axiom that the microcosm is made in the image of the universe. Fludd conveys his ideas through powerful visual images,[8] and his diagrams of the creation of the universe look like a sunflower. Two instances will suffice to illustrate Kiefer's interest in this almost unremembered English writer: his treatment of the contrast between light and dark, and his cross-referencing between macrocosm and microcosm. When Kiefer attaches little labels bearing the names of stars to black sunflower heads, seen as if back-lit against bright backgrounds, he is using the flower forms metaphorically, in order to present a view of the sky that reverses the natural state of things: dark stars, white background. This alienation device fascinates, but it also confuses—as does the enigmatic, reclining figure beneath the giant plant. The use of woodcut technique in these works intensifies the contrast and emphasizes the reversal.[9] While the names and the connecting lines stand for a systematic and objective handling of the subject, they also evoke visions of the imagination, mythopoetic images; one hears "the noise of time".[10]

In 1995–96, Kiefer took up the Romantic topic of night and the starry firmament in a number of over-whelming landscapes.[11] The large formats invite us to plunge into alien spaces, in which the encounter between heaven and earth is seen in a new light. Yet, like the sunflowers, they emanate a disquiet that tends to grow. To what extent is everything also its own opposite? Always? White is not to be trusted; sleep can look like death; the stars fall down—black and extinct, as Hildegard of Bingen had her artist show them.[12] Intensified by the notion of a totally interconnected macrocosm and microcosm, of an infinitely complex tissue of the universe, for which "our weak capacities" (Fludd) lack the necessary powers of discrimination, the awareness of a universally impending danger imposes itself, stronger than hope, and the paintings acquire a powerful actuality. Many of them reiterate the triadic harmony of the elements, sky, earth and water (cat. 21, pp. 78–79). But the ascending gaze must return, cast ashore by the tides, into the revelation of the stars in water, entangled in a web of fact and speculation, knowledge and illusion.[13] And what are the names of the stars? Alphanumeric combinations, freshly assigned by NASA! These are "authentic", like the sunflower seeds on the canvas, and among them stand Orion and Taurus, the Bull, the Scorpion—constellations and zodiacal signs handed down from Babylon, Egypt and Greece. Kiefer retraces their shapes and casts a magical web across the teeming background, a celestial geometry with intersections and fixed points. When plant life grows there, or blooms scatter across the dark, the poetic substance of Fludd's vision unfolds—"every Plant has his Related Star in the Sky"—and the night sky pulsates as the most wondrous projection screen for the human imagination. Where fluttering garments appear among the names, the artist calls them "the Unborn": an echo of the Platonic notion of the immaterial, preexistent soul, who flies around until she "at last settles on the solid ground—there, finding a home, she receives an earthly frame which appears to be self-moved, but is really moved by her power".[14]

Lichtzwang (*Light Compulsion*) is the title of the most important painting in this cycle (cat. 20, pp. 80–81). Centred, diaphanous, written in white chalk, the title stands high above the Milky Way, which rears its soft, cloudy arch across the sparkling firmament. Above left, we read the words "für Paul Celan". Kiefer thus

dedicates his finest Star Painting to the poet. It is monumental, limitless on all sides, with many centres, like Pollock's multifocal spaces; and yet it remains a celestial map, observing due proportion. We might lose ourselves in dark deeps and feathery nebulae; but there are the fixed points, and a few stars shine more brightly. Their names, like signposts, help us to gain our bearings. Are the lines walkable? Make your way along Cassiopeia and look for the Hesperides. Where is the Great Bear? These lines are puzzling. Almost all are straight; some lead back to the beginning; some break off abruptly. Suddenly, there are the little garments in the centre, floating down. Down to where? Further up, beyond the Milky Way, there is something reddish, like fire, like a trace of blood: Mars, the god of war, is named in big, legible letters. The names, the signs, emphasize the flatness of the surface. They bring us back to the Here and Now.

Lichtzwang is the title of a book of verse by Paul Celan, prepared for press by the poet himself and published posthumously in 1970. It consists of six parts, each containing between eight and sixteen poems. Kiefer never illustrates. It would be wrong to draw an analogy between the bright river that runs across this sky and the river in which the poet assuaged his longing for death. But the idiosyncratically clear and yet enigmatic lines and figures on the firmament, in which ancient mythical images are linked together with numbers and letters, seem to afford a correspondence with Celan's work. As the poet explained in 1958, "This language—for all its inherent multiplicity of utterance—aims at precision. It does not transfigure ... it seeks to measure the scope of the given and of the possible."[15] Kiefer's dedication reveals how much he values Celan; his title, *Lichtzwang*, reiterates a word that reflects the poet's fate.

1 Immanuel Kant, *Kritik der praktischen Vernunft*, 1788, in Kant, *Werke*, ed. Wilhelm Weischedel, Frankfurt am Main 1977, vol. 7, p. 300. The correct wording is "Der bestirnte Himmel über mir, und das moralische Gesetz in mir." Kiefer has involuntarily misquoted Kant's sentence, which has become a middlebrow bourgeois cliché. Cf. also other works of the same period with starry backdrops, such as: *Kleine Panzerfaust Deutschland für Chlebnikow* (*Little Tank Fist Germany for Khlebnikov*) 1980, 83 x 58 cm.
2 Works of 1996 such as *Dat Rosa Mel Apibus* (*The Rose Gives Honey to the Bees*), 280 x 380 cm, in which the figure is located at the centre of the concentric circles of a cosmogram, are even more overtly diagrammatic. Cf., e.g., Robert Fludd, *Utriusque cosmi maioris scilicet et minoris Metaphysica, physica atque technica Historia. Tomus primus, De macrocosmi Historia in duos tractatus diuisa*, vol. I, Oppenheim: De Bry, 1617, title page.
3 Thomas McEvilley, "Communion and Transcendence in Kiefer's New Work: Simultaneously Entering the Body and Leaving the Body", in *Anselm Kiefer. I Hold All Indias in my Hand*, exh. cat., Anthony d'Offay Gallery, London 1996. He here refers to Patañjali (*Yoga Sutra* 1.2).
4 Cf. Anselm Kiefer, *Heliogabal*, 1974, watercolour, 30 x 40 cm, and *Sol invictus Helah-Gabal*, potato-print book, 1974.
5 Robert Fludd (Robertus de Fluctibus), Bearsted, Kent 1574 – London 1637. In his world-view, as described most notably in his magnum opus, *De utriusque cosmi*, which is not based on astronomical calculations, Fludd combines Neoplatonic, theological and alchemical notions. His stubborn adherence to the geocentric world-view was criticized, notably by Kepler in 1619 and 1622.
6 A. G. Debus, "The Sun in the Universe of Robert Fludd", in *Le soleil à la Renaissance. Sciences et Mythes:* International colloquium, Brussels 1965, p. 266.
7 Nikolaus von Kues (Nikolaus Chryfftz or Krebs, Kues/Mosel 1401–1464 Todi). In his treatise *De coniecturis* (On Conjectures), c. 1440, he set out his theory of four levels of cognition in two diagrams: "The *Figura Paradigmatica* represents the universe through the interpenetration of two pyramids, the bases of which he names Unity (*unitas*) and Otherness (*alteritas*). In these two, he says, all other oppositions are contained: God and Nothingness, Light and Darkness, Possibility and Reality, General and Particular, Male and Female. Ascent and Descent, Evolution and Involution, are one and the same. The advance of one is the retreat of the other." Alexander Roob, *Das hermetische Museum. Alchemie & Mystik*, Cologne 1996, p. 274.
8 Flood (as note 2), illustrated in the Oppenheim ed. of 1617 by Matthias Merian.
9 In his early work, Kiefer made a decisive contribution to the revival of this technique and its use on a monumental scale in contemporary art.
10 Osip Mandelstam, *The Noise of Time*, San Francisco 1986; in German, the phrase is "das Rauschen der Zeit".
11 See, among others, *Cette obscure clarté qui tombe des étoiles* (*This Dark Light Falling from the Stars*), 1996, 480 x 430 cm; *Die Sechste Posaune* (*The Sixth Trumpet*), 1996, 520 x 560 cm.
12 St Hildegard of Bingen, *Liber Scivias*, Book III, Vision III.2, *The Almighty and the Extinct Stars*. Rupertsberg MS, twelfth century.
13 On the nature of the lines drawn to link the stars, or the flowers that stand for stars, see, among others, Anastasius Kircher, *Ars magna lucis*, Rome 1665. The rays of light stand for degrees of enlightenment.
14 Plato, *Phaidros*, 25, 246, c; quoted from Plato, *Phaedrus*, trans. by Benjamin Jowett, http://ccat.sas.upenn.edu/jod/texts/phaedrus.html.
15 "*Dieser Sprache geht es bei aller unabdingbaren Vielseitigkeit des Ausdrucks, um Präzision. Sie verklärt nicht, ... sie versucht, den Bereich des Gegebenen und des Möglichen auszumessen.*" Paul Celan, "Antwort auf eine Umfrage der Galerie Flinker, Paris (1958)", in Celan, *Gesammelte Werke*, vol. 3, Frankfurt am Main 2000, p. 167.

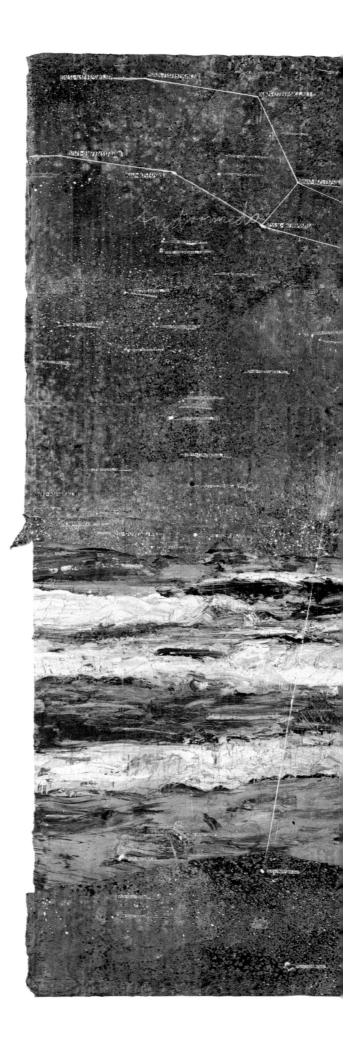

7 Der gestirnte Himmel, 1980 *The Starred Heaven*
Acrylic and emulsion on photograph (1969), 83 x 58.5 cm

21 Andromeda, 2001
Oil, emulsion, acrylic and chalk on lead on canvas, 395 x 500 cm

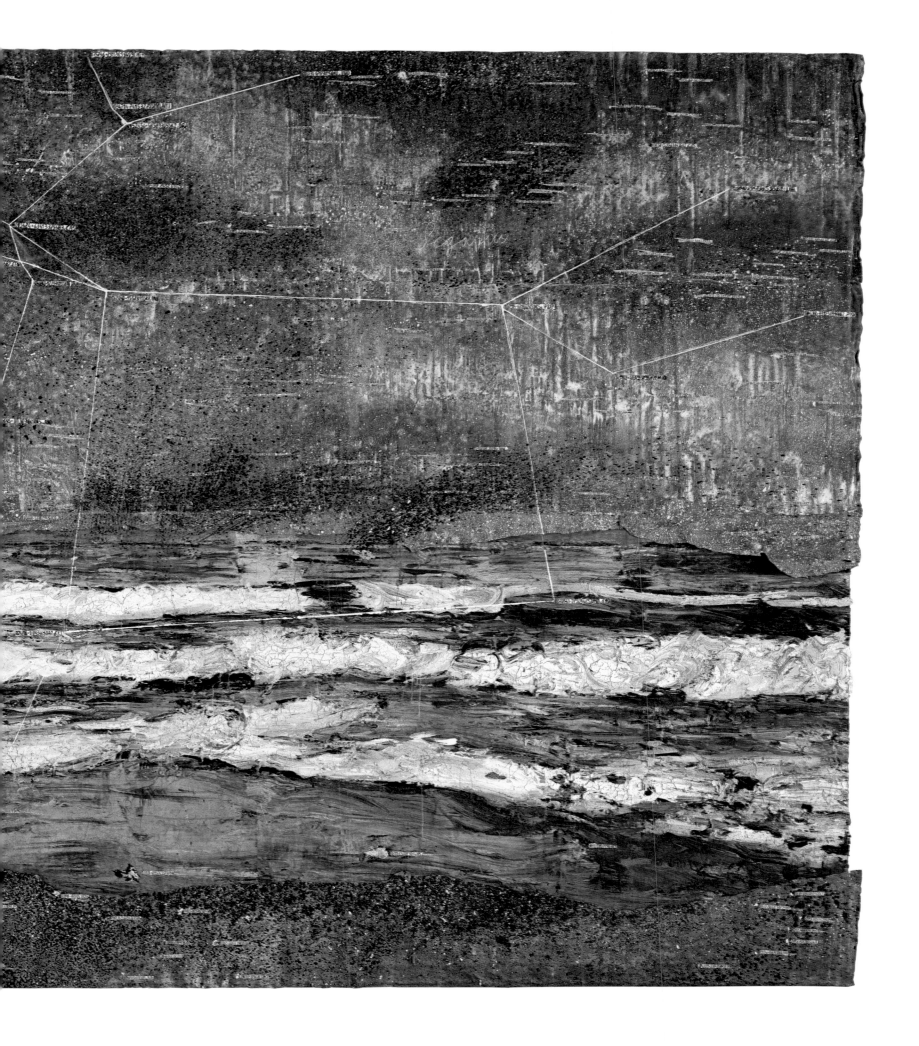

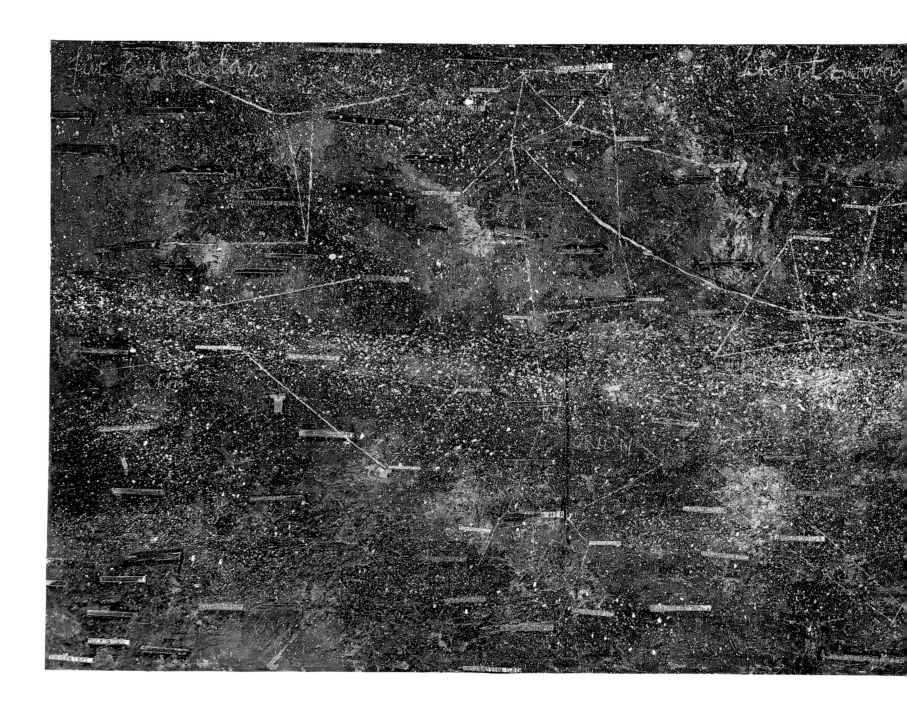

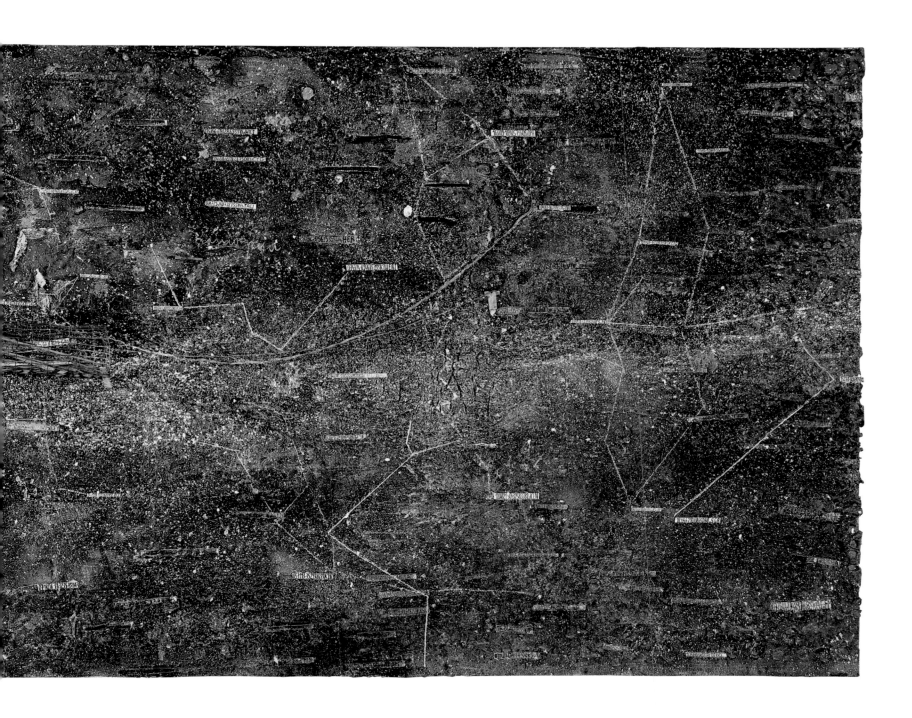

20 Lichtzwang, 1999 *Light Compulsion*
Oil, acrylic, emulsion, shellac, ash, paper and metal objects, glass and lead on canvas, 279.5 x 759.5 cm

19 The secret life of plants, 1998
Acrylic, shellac, sunflower seeds and emulsion on canvas, 330 x 700 cm

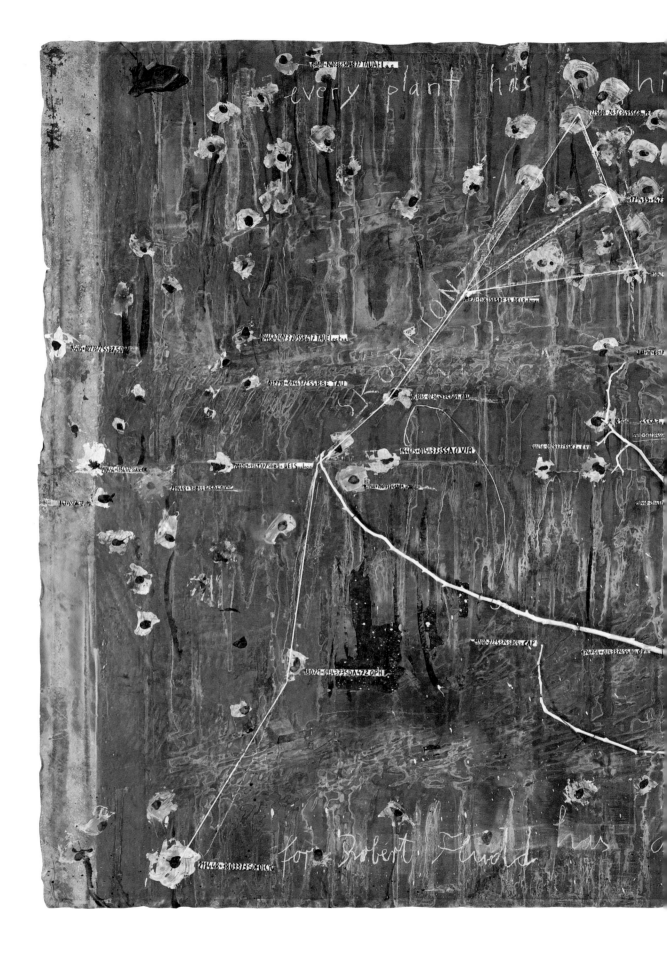

22 Every plant has his related star in the sky, 2001
Oil, emulsion, acrylic and chalk on lead on canvas, with plaster-covered plants, 194 x 336 cm

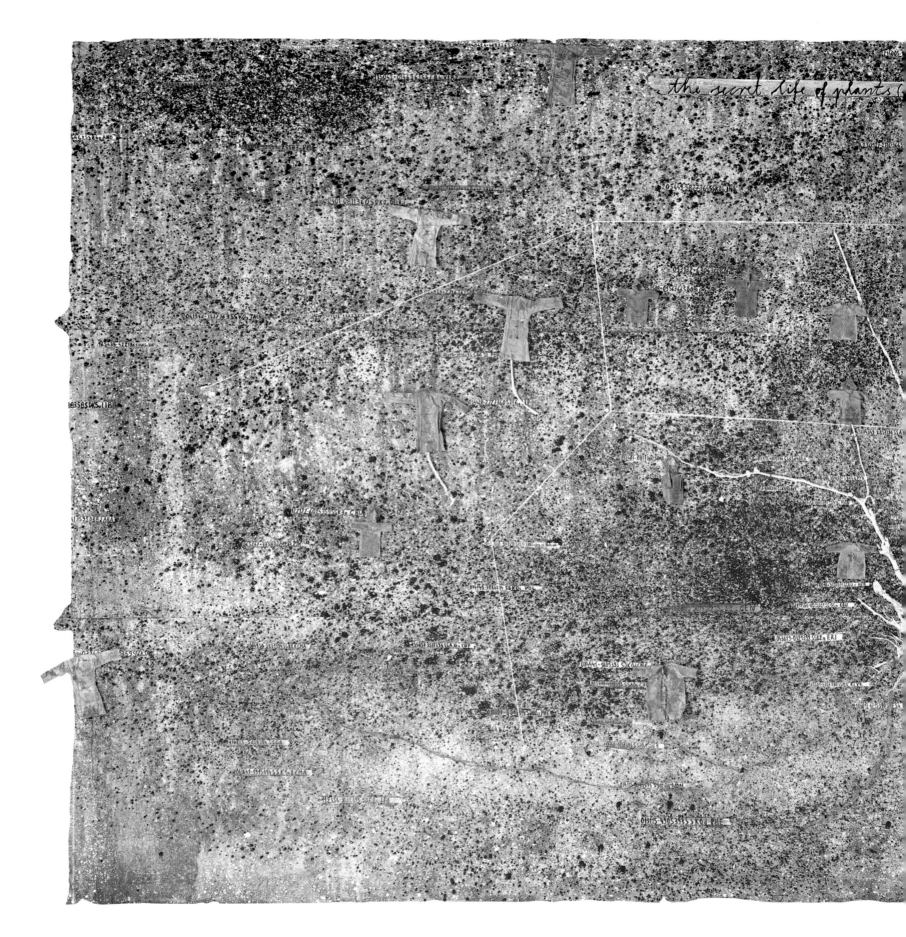

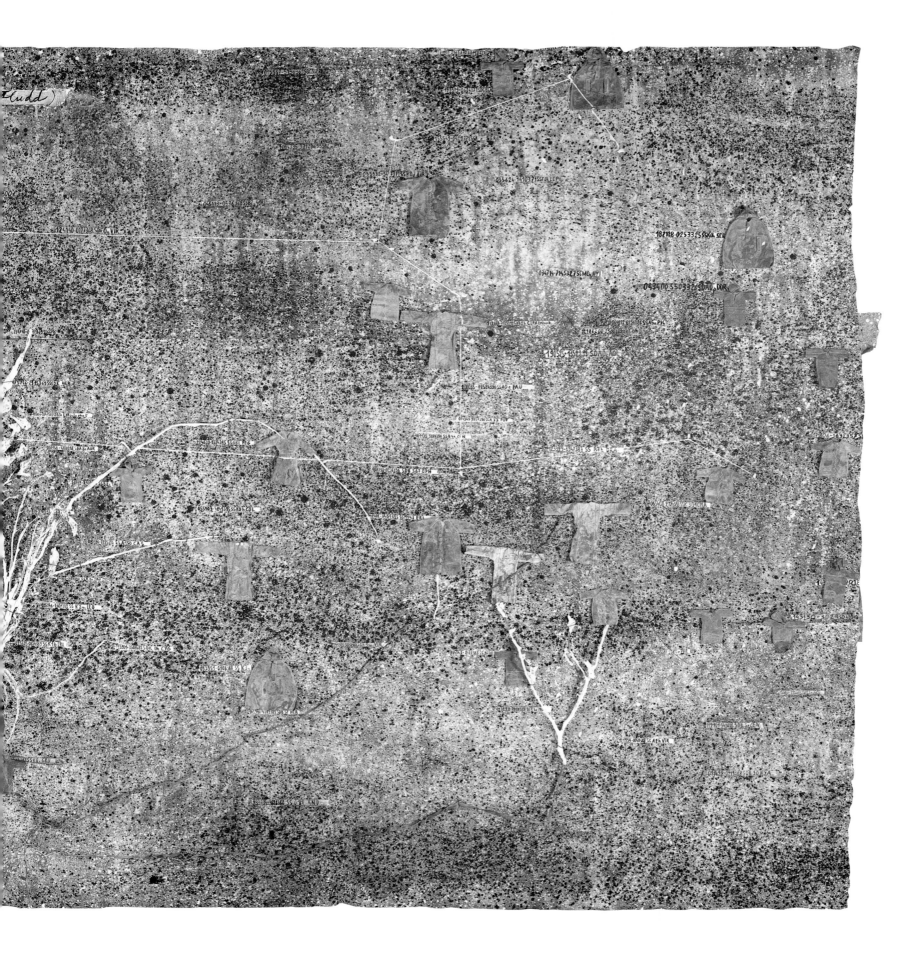

23 The secret life of plants, 2001
Oil, emulsion, acrylic and chalk on lead on canvas, with plaster-covered plants and lead, 290 x 575 cm

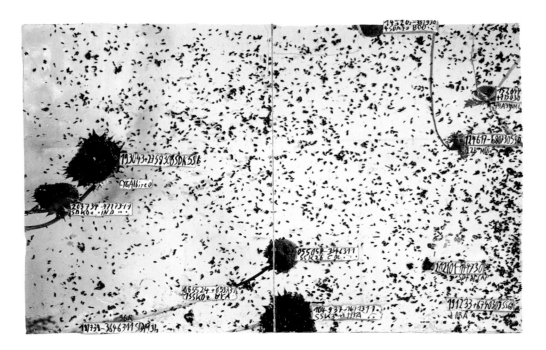

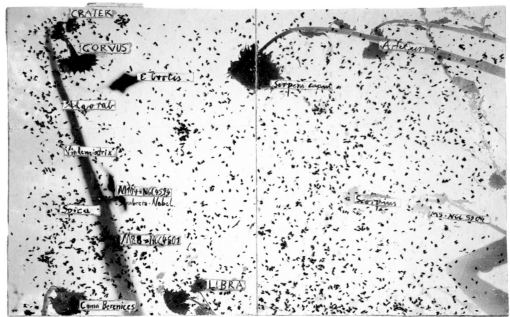

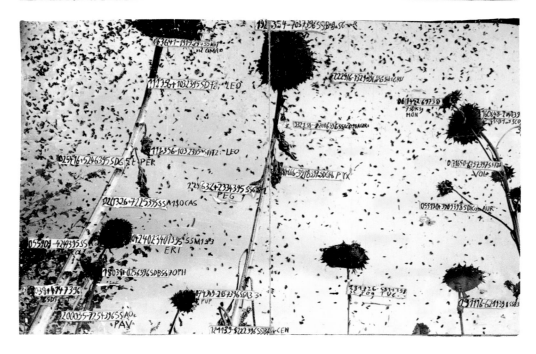

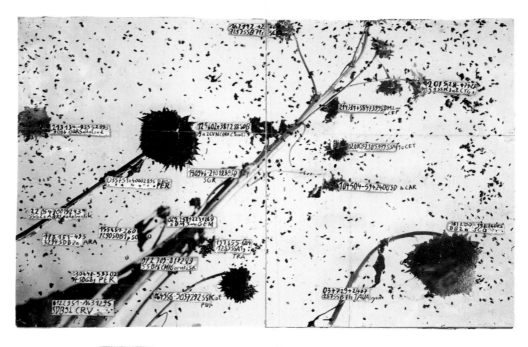

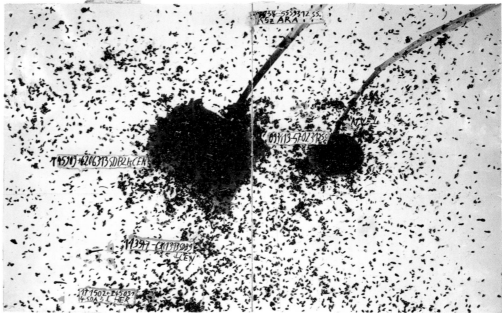

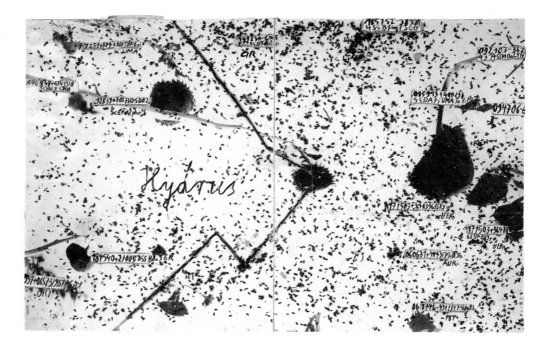

17 The secret life of plants, 1997
(Book)
Sunflower seeds on photographs on
cardboard, 103.5 x 80.5 x 8 cm

Insofar as there is a modern age, it is the age of all things cosmic.

Gilles Deleuze/Félix Guattari

14 Sol invictus, 1995
Sunflower seeds and emulsion on burlap, 476 x 280 cm

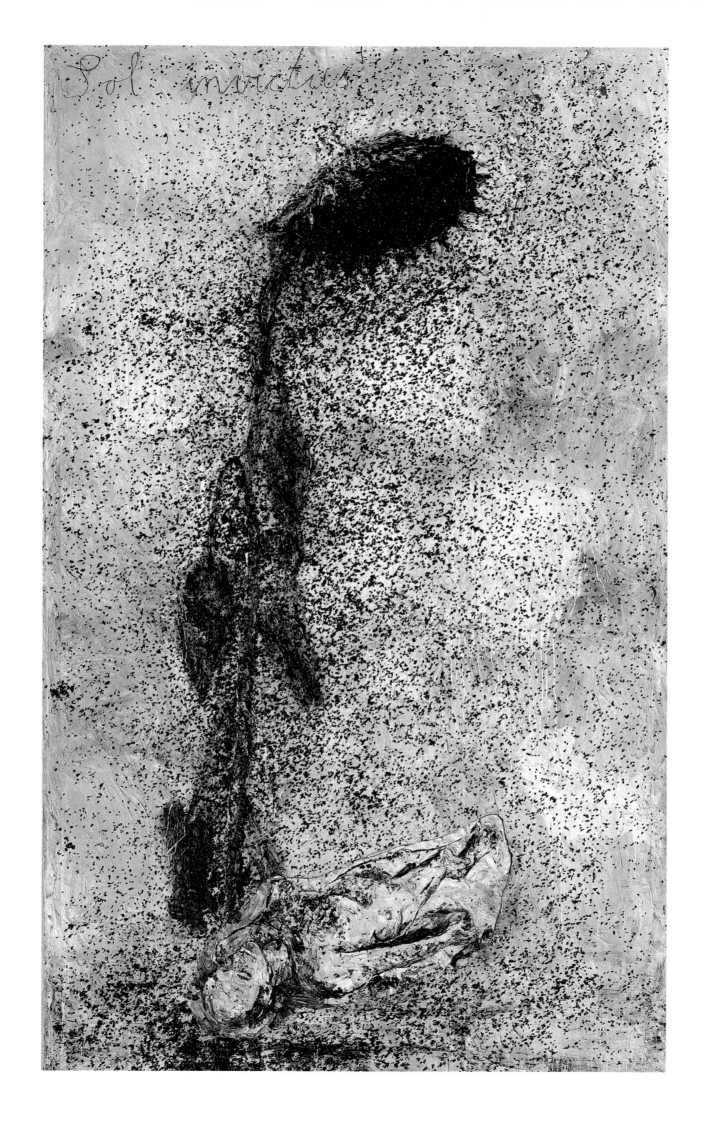

Die Himmelspaläst

 # Seven Heavenly Palaces: Gouaches 2001

Massekhet Hekhalot. Tract of the Heavenly Palaces

And between them are set the seven palaces
of the seven adorned,
this one within that
and that one within this.

All are (full of) burning
coals,
torchlight,
sparks
and lightning,
pillars of fire,
columns of burning coals,
pillars of flame,
pillars of embers
pillars of lightning
and pillars of torchlight
as high as (the distance) from
the earth to the height of the highest
raqia'.

In each one of the palaces there are
8,766 gates of lightning,
corresponding to the number of hours
of the days of the year.
The height of each gate is as the height of the seven
 reqi'im,
and their width is as the length and breadth of the
 world.

Above each one of the entrances
in the palaces of the *'aravot*
there are 360,000 myriad types of lamps
set like the great lamp
that illuminates the (whole) world with its brightness
that no creature can gaze upon.

Above each one of the entrances
rise 365,000 myriad ministering angels
that rise as high as (the distance) from the earth
to the height of the *raqia'*.

26 Die Himmelspaläste, 2001 *The Heavenly Palaces*
Emulsion and charcoal on photograph, 110 x 113 cm

32 Sefer Hehaloth, 2001
Emulsion and charcoal on photograph, 123 x 126.5 cm

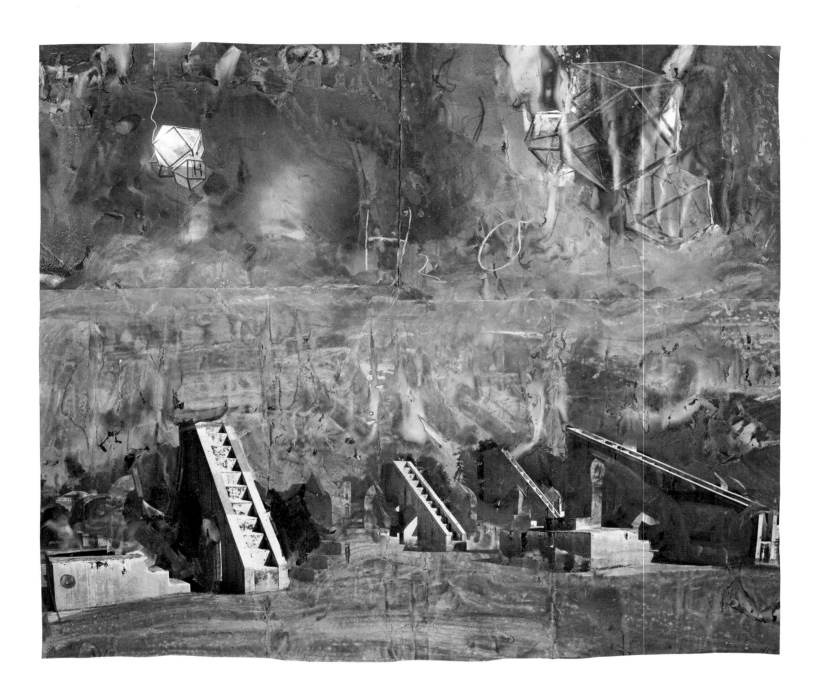

28 H^2O, 2001
Emulsion and charcoal on photograph, 93 x 108 cm

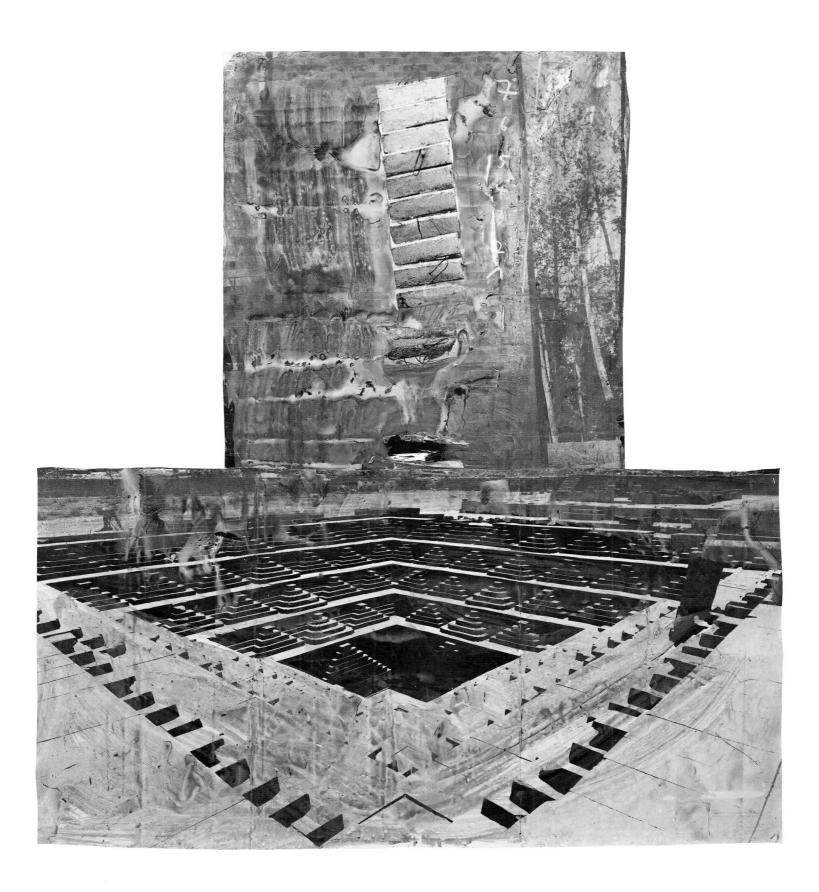

34 Steigend, steigend sinke nieder, 2001 *Ascending, Ascending Sink Down*
Emulsion and charcoal on photograph, 129.5 x 117 cm

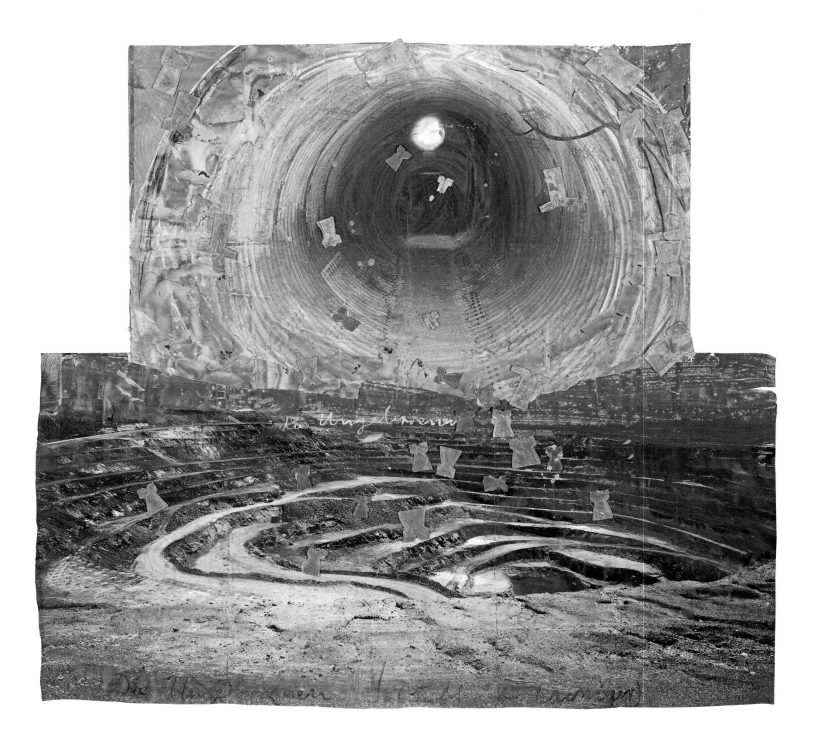

27 Die Ungeborenen, 2001 *The Unborn*
Emulsion, charcoal and lead on photograph, 107.5 x 116.5 cm

31 Sefer Hechaloth, 2001
Emulsion and charcoal on photograph, 56 x 79.5 cm

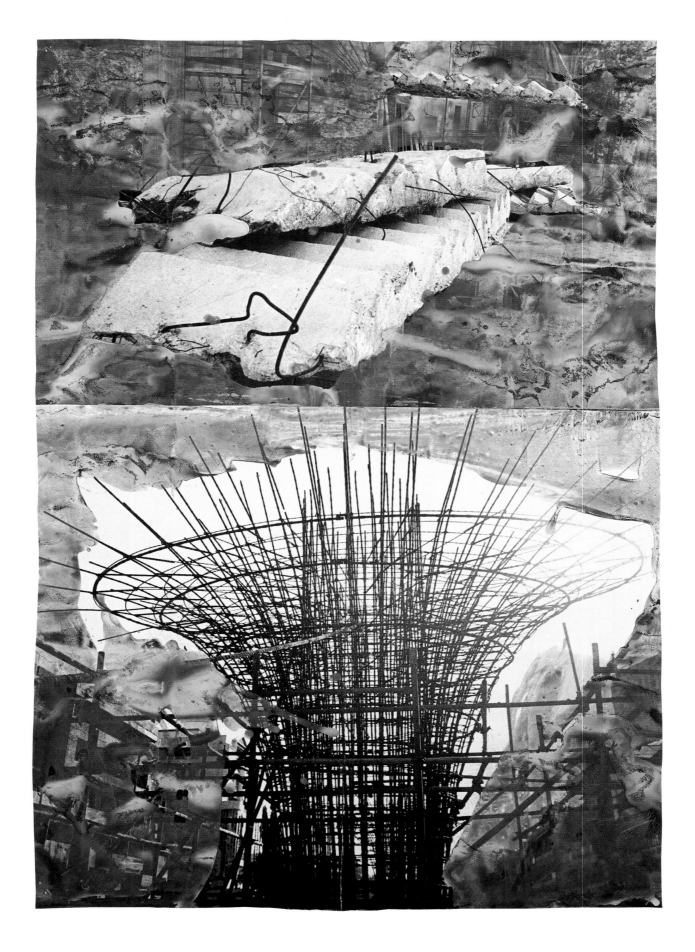

30 Nagpur, 2001
Emulsion and charcoal on photograph, 111 x 78 cm

Appendix

List of Works

Anselm Kiefer
born 1945 in Donaueschingen, Germany. Studied art at the
Staatliche Hochschule der Bildenden Künste in Freiburg with
Peter Dreher, in Karlsruhe with Horst Antes and subsequently
at the Kunstakademie in Düsseldorf with Joseph Beuys from
1966–72. From 1971 on Kiefer worked in the Odenwald. He
moved to Barjac in France in 1992/93 where he has lived and
worked ever since.

1 Die Tür, 1973
 The Door
 Charcoal, oil and hare's fur on burlap, 300 x 220 cm;
 118 1/8 x 86 5/8 in
 KunstMuseum Bonn, permanent loan Collection Grothe
 Ill. p. 45

2 Notung, 1973
 Nothung
 Chalk, oil and paper fitted in on canvas, 300 x 432 cm;
 118 1/8 x 170 in
 Museum Boijmans Van Beuningen, Rotterdam
 Ill. pp. 46–47

3 Parsifal III, I, IV, 1973
 Oil, partially blood (I, IV) and paper fitted in on paper on canvas
 (triptych)
 III: 332 x 228 cm, I: 307 x 435.5 cm, IV: 327.6 x 227 cm;
 III: 130 3/4 x 89 3/4 in, I: 120 7/8 x 171 1/4 in,
 IV: 129 x 89 3/8 in
 Tate, purchased 1982
 Ill. pp. 42–43

4 Resurrexit, 1973
 Charcoal, oil and acrylic on burlap, 290 x 180 cm;
 114 3/16 x 70 7/8 in
 Collection Sanders, Amsterdam
 Ill. p. 41

5 Grab des unbekannten Malers, 1974
 Tomb of the Unknown Painter
 Oil, emulsion and synthetic resin on burlap, 115 x 161 cm;
 45 1/4 x 63 3/8 in
 KunstMuseum Bonn, permanent loan Collection Grothe
 Ill. p. 48

6 Bilder-Streit, 1980
 Iconoclastic Controversy
 Oil, sand, woodcut and photograph on burlap, 290 x 400 cm;
 114 3/16 x 157 1/2 in
 Museum Boijmans Van Beuningen, Rotterdam
 Ill. p. 49

7 Der gestirnte Himmel, 1980
 The Starred Heaven
 Acrylic and emulsion on photograph (1969), 83 x 58.5 cm;
 32 7/8 x 23 in
 Collection Eric Fischl
 Ill. p. 78

8 Des Malers Atelier, 1980
 The Painter's Studio
 Chalk, graphite pencil and acrylic (or oil) on photograph (1971),
 58.5 x 68 cm; 23 x 26 3/4 in
 Graphische Sammlung – Staatsgalerie Stuttgart,
 Collection Dr. Rolf H. Krauss
 Ill. p. 40

9 Die Treppe, 1982/83
 The Stairs
 Emulsion, shellac, straw and traces of fire on photograph on
 canvas, 330 x 185 cm; 129 7/8 x 72 7/8 in
 KunstMuseum Bonn, permanent loan Collection Grothe
 Ill. p. 55

10 Dem unbekannten Maler, 1983
 To the Unknown Painter
 Oil, acrylic, emulsion, shellac and straw on canvas,
 208 x 381 cm; 81 7/8 x 150 in
 KunstMuseum Bonn, permanent loan Collection Sylvia and
 Ulrich Ströher, Darmstadt
 Ill. pp. 56–57

11 Grab des unbekannten Malers, 1983
 Tomb of the Unknown Painter
 Oil, emulsion, shellac, latex and straw on canvas, 133 x 229 cm;
 52 3/8 x 90 3/16 in
 Astrup Fearnley Collection, Oslo
 Ill. p. 54

12 *Untitled*, 1983
 Emulsion, oil, shellac, woodcut, synthetic resin and straw on
 canvas, 260 x 190 cm; 102 3/8 x 74 13/16 in
 Staatliche Museen zu Berlin, Nationalgalerie, Collection Marx
 Ill. p. 59

13 Sulamith, 1983
 Shulamite
 Oil, emulsion, shellac, acrylic, straw and woodcut on canvas,
 290 x 370 cm; 114 3/16 x 145 5/8 in
 Private collection, San Francisco
 Ill. pp. 60–61

14 Sol invictus, 1995
 Sunflower seeds and emulsion on burlap, 476 x 280 cm;
 187 3/8 x 110 1/4 in
 Private collection
 Ill. p. 91

15 Dein und mein Alter und das Alter der Welt, 1997
 Your Age and My Age and the Age of the World
 Oil, emulsion, shellac, ash and applied terra-cotta on canvas,
 470 x 900 cm; 185 x 354 1/2 in
 Courtesy Anthony d'Offay Gallery, London
 Ill. pp. 68–69

16 Der Sand aus den Urnen, 1997
 The Sand from the Urns
 Emulsion, acrylic, shellac, clay and sand on canvas,
 280 x 560 cm; 110 1/4 x 220 1/2 in
 Private collection
 Ill. pp. 70–71

17 The secret life of plants, 1997 (7 Books)
Sunflower seeds on photographs on cardboard,
103.5 x 80.5 cm; 40 3/4 x 31 11/16 in
Private collection
Ill. pp. 88–89

18 Wach im Zigeunerlager und wach im Wüstenzelt,
es rinnt uns der Sand aus den Haaren, 1997
*Awake in the Gypsy Camp and Awake in the Desert Tent,
the Sand Trickles out of our Hair*
Emulsion, acrylic, shellac, burnt clay, sand and iron on canvas,
280 x 560 cm; 110 1/4 x 220 1/2 in
Private collection
Ill. pp. 72–73

19 The secret life of plants, 1998
Acrylic, shellac, sunflower seeds and emulsion on canvas,
330 x 700 cm; 129 7/8 x 275 5/8 in
Private collection
Ill. pp. 82–83

20 Lichtzwang, 1999
Light Compulsion
Oil, acrylic, emulsion, shellac, ash, paper and metal objects,
glass and lead on canvas, 279.5 x 759.5 cm; 110 x 299 in
Private collection
Ill. pp. 80–81

21 Andromeda, 2001
Oil, emulsion, acrylic and chalk on lead on canvas,
395 x 500 cm; 155 1/2 x 196 7/8 in
Private collection
Ill. pp. 78–79

22 Every plant has his related star in the sky, 2001
Oil, emulsion, acrylic and chalk on lead on canvas, with plaster-
covered plants, 194 x 336 cm; 76 3/8 x 132 5/16 in
Private collection
Ill. pp. 84–85

23 The secret life of plants, 2001
Oil, emulsion, acrylic and chalk on lead on canvas, with plaster-
covered plants and lead, 290 x 575 cm; 114 3/16 x 226 3/8 in
Private collection
Ill. pp. 86–87

New Gouaches on the Theme of the Exhibition

24 Assumption, 2001
Emulsion and charcoal on photograph,
115 x 127 cm; 45 1/4 x 50 in
Private collection
not illustrated

25 Berenice, 2001
Emulsion, charcoal and hair on photograph,
121.5 x 116 cm; 47 7/8 x 45 5/8 in
Private collection
not illustrated

26 Die Himmelspaläste, 2001
The Heavenly Palaces
Emulsion and charcoal on photograph,
110 x 113 cm; 43 5/16 x 44 1/2 in
Private collection
Ill. p. 94

27 Die Ungeborenen, 2001
The Unborn
Emulsion, charcoal and lead on photograph,
107.5 x 116.5 cm; 42 5/16 x 45 7/8 in
Private collection
Ill. p. 98

28 H^2O, 2001
Emulsion and charcoal on photograph,
93 x 108 cm; 36 5/8 x 42 1/2 in
Private collection
Ill. p. 96

29 Jacobs Traum, 2001
Jacob's Dream
Emulsion, charcoal and lead on photograph,
108 x 103 cm; 42 1/2 x 40 1/2 in
Private collection
not illustrated

30 Nagpur, 2001
Emulsion and charcoal on photograph,
111 x 78 cm; 43 11/16 x 30 11/16 in
Private collection
Ill. p. 100

31 Sefer Hechaloth, 2001
Emulsion and charcoal on photograph,
56 x 79.5 cm; 22 1/16 x 31 5/16 in
Private collection
Ill. p. 99

32 Sefer Hehaloth, 2001
Emulsion and charcoal on photograph,
123 x 126.5 cm; 48 3/8 x 49 13/16 in
Private collection
Ill. p. 95

33 Sefer Hechaloth, 2001
Emulsion and charcoal on photograph,
126.5 x 112.5 cm; 49 13/16 x 44 5/16 in
Private collection
not illustrated

34 Steigend, steigend sinke nieder, 2001
Ascending, Ascending Sink Down
Emulsion and charcoal on photograph,
129.5 x 117 cm; 51 x 46 in
Private collection
Ill. p. 97

Selected Exhibitions

* refers to an exhibition publication

Solo Exhibitions

2001

Fondation Beyeler, Riehen/Basel. »Anselm Kiefer. *die* sieben HimmelsPaläste 1973–2001«*
(Cat.: texts by Christoph Ransmayr, Markus Brüderlin, Mark Rosenthal and Katharina Schmidt)
Louisiana Museum of Modern Art, Humlebæk. "Anselm Kiefer: Paintings 1998–2000"*
(Cat.: text by Thomas McEvilley)
Le Rectangle, Lyon. "Anselm Kiefer: Les Reines de France"*

2000

Chapelle de la Salpêtrière, Festival d'Automne à Paris. "Chevirat Ha-Kelim. Le bris des vases. Anselm Kiefer"*
(Cat.: text by Catherine Strasser)
Stedelijk Museum voor Actuele Kunst, Ghent. "Anselm Kiefer: Recent Works 1996–1999"*
(Cat.: text by Danilo Eccher)
Anthony d'Offay Gallery, London. "Anselm Kiefer: Let a Thousand Flowers Bloom"*
(Cat.: text by Thomas McEvilley)
Gagosian Gallery, New York. "Anselm Kiefer"

1999

Galleria d'Arte Moderna di Bologna. "Anselm Kiefer: Stelle cadenti"*
(Cat.: text by Danilo Eccher)
Galerie Yvon Lambert, Paris. "Anselm Kiefer: Die Frauen der Antike"*
(Cat.: text by Bernard Comment)

1998

The Metropolitan Museum of Art, New York. "Anselm Kiefer: Works on Paper in The Metropolitan Museum of Art"*
(Cat.: text by Nan Rosenthal)
Gagosian Gallery, New York. "Anselm Kiefer: Dein und Mein Alter und das Alter der Welt/Your Age and Mine and the Age of the World"*
(Cat.: text by Heiner Bastian)
Museo Nacional Centro de Arte Reina Sofía (Palacio de Velázquez), Madrid. "El viento, el tiempo, el silencio"*
(Cat.: texts by Alicia Chillida, Olvido García Valdés, José Alvarez and Fernando Castro Flórez)

1997

Museo Correr, Venice. "Anselm Kiefer: Himmel-Erde"*
(Cat.: texts by Massimo Cacciari and Germano Celant)
Museo e Gallerie Nazionale di Capodimonte, Naples. "Anselm Kiefer: Holzschnitte (1993–1996)"*
(Cat.: texts by Lia Rumma and Nicola Spinosa)

1996

Centro Cultural Arte Contemporáneo, Ciudad de México. "Del Paisaje a la Metaphora. Anselm Kiefer en Mexico. Pinturas y Libros Del Artista Aleman"*
(Cat.: texts by Robert R. Littman and Mary Lou Dabdoub)
Galerie Yvon Lambert, Paris. "Anselm Kiefer: Cette obscure clarté qui tombe des étoiles"*
(Cat.: text by Daniel Arasse)
South London Gallery, Anthony d'Offay Gallery, London. "Anselm Kiefer: I Hold All Indias in My Hand"*
(Cat.: text by Thomas McEvilley)

1995

Kukje Gallery, Seoul. "Anselm Kiefer 1982–1995"*

1993

Sezon Museum of Art, Tokyo, The National Museum of Modern Art Kyoto, Hiroshima City Museum of Contemporary Art. "Anselm Kiefer: Melancholia"*
(Cat.: texts by Mark Rosenthal and Takashi Hiraide et al.)
Marian Goodman Gallery, New York. "Anselm Kiefer: Twenty Years of Loneliness"*

1992

Anthony d'Offay Gallery, London. "Anselm Kiefer: The Women of the Revolution"
Galleria Lia Rumma, Naples. "Anselm Kiefer"
Fuji Television Gallery, Tokyo. "Anselm Kiefer: The Winged Zeitgeist"*
(Cat.: text by Tatsumi Shinoda)

1991

Nationalgalerie Berlin, Staatliche Museen zu Berlin – Preußischer Kulturbesitz. "Anselm Kiefer"*
(Cat.: texts by Dieter Honisch, Doreet LeVitté-Harten, Wulf Herzogenrath, Angela Schneider, Anda Rottenberg and Peter-Klaus Schuster)
Marian Goodman Gallery, New York. "Anselm Kiefer: Lilith"*
(Cat.: text by Doreet LeVitté-Harten)
Galerie Yvon Lambert, Paris. "Anselm Kiefer: Nachtschattengewächse"*
(Cat.: text by Jean-Noël Vuarnet)

1990

Städelsches Kunstinstitut, Frankfurt/M. "Anselm Kiefer: Über Räume und Völker"*
Kunsthalle Tübingen, Kunstverein Munich, Kunsthaus Zürich. "Anselm Kiefer: Bücher 1969–1990"*
(Cat.: texts by Götz Adriani, Peter Schjeldahl, Toni Stooss and Zdenek Felix)
Mönchehaus-Museum für moderne Kunst, Goslar. "Anselm Kiefer: Zur Verleihung des Goslarer Kaiserrings am 20. Oktober 1990"*
(Cat.: text by Doreet LeVitté-Harten)
Israel Museum, Jerusalem. "Mohn und Gedächtnis"*
(Cat.: text by Heiner Bastian)

1989

Galerie Paul Maenz, Cologne. "Anselm Kiefer: Der Engel der Geschichte"
Anthony d'Offay Gallery, London et al. "Anselm Kiefer: The High Priestess/Zweistromland"*
(Cat.: texts by Armin Zweite and Anne Seymour)
Galeria Foksal, Warsaw. "Anselm Kiefer: Mohn und Gedächtnis"*
(Cat.: texts by Stanislaw Cichowicz and Andrzej Plenkos)

1987

The Art Institute of Chicago, Philadelphia Museum of Art, Los Angeles Museum of Contemporary Art, Museum of Modern Art, New York. "Anselm Kiefer"*
(Cat.: text by Mark Rosenthal)
Marian Goodman Gallery, New York. "Anselm Kiefer: Bruch und Einung"*
(Cat.: text by John Hallmark Neff)
Galerie Foksal, Warsaw. "Anselm Kiefer"*
(Cat.: text by Wieslaw Borowski)

1986

Stedelijk Museum, Amsterdam. "Anselm Kiefer: Bilder 1986–>1980"*
(Cat.: text by Wim Beeren)
Galerie Paul Maenz, Cologne. "Anselm Kiefer"*
(Cat.: text by Gudrun Inboden)

1984

Städtische Kunsthalle Düsseldorf, ARC – Musée d'Art Moderne de la Ville de Paris, Israel Museum, Jerusalem. "Anselm Kiefer"*
(Cat.: texts by Rudi H. Fuchs, Suzanne Pagé and Jürgen Harten)
C.A.P.C. Musée d'Art Contemporain, Bordeaux. "Anselm Kiefer: Peintures 1983–1984"*
(Cat.: texts by René Denizot and J. L. Froment)

1983

Sonja Henie/Niels Onstad Foundations, Oslo. "Anselm Kiefer"
Anthony d'Offay Gallery, London. "Anselm Kiefer: Paintings and Watercolours 1970–1982"*
(Cat.: text by Anne Seymour)
Hans-Thoma-Museum, Bernau/Black Forest. "Anselm Kiefer: Bücher und Gouachen. Eine Ausstellung aus Anlaß der Verleihung des Hans-Thoma-Preises"*
(Cat.: text by Katharina Schmidt)

1981

Museum Folkwang Essen, Whitechapel Art Gallery, London. "Anselm Kiefer: Bilder und Bücher"*
(Cat.: texts by Zdenek Felix and Nicholas Serota)
Freiburger Kunstverein, Freiburg. "Anselm Kiefer: Aquarelle 1970–1980"*
(Cat.: text by Rudi H. Fuchs)
Galerie Paul Maenz, Cologne. "Anselm Kiefer: Urd, Werdandi, Skuld"

Marian Goodman Gallery, New York. "Anselm Kiefer"

1980
La Biennale di Venezia, 39. Esposizione internazionale d'arte, German Pavilion. "Anselm Kiefer: Verbrennen, verholzen, versenken, versanden"*
(Cat.: texts by Klaus Gallwitz and Rudi H. Fuchs)
Württembergischer Kunstverein Stuttgart. "Anselm Kiefer"*
(Cat.: text by Tilman Osterwold)
Groninger Museum, Groningen. "Anselm Kiefer"*
(Cat.: texts by Carel Blotkamp and Günther Gercken)
Mannheimer Kunstverein, Mannheim. "Anselm Kiefer"*
(Cat.: text by Rudi H. Fuchs)

1979
Stedelijk Van Abbemuseum, Eindhoven. "Anselm Kiefer"*
(Cat.: text by Rudi H. Fuchs)

1978
Kunsthalle Bern. "Anselm Kiefer: Bilder und Bücher"*
(Cat.: texts by Johannes Gachnang and Theo Kneubühler)

1977
Galerie Helen van der Meij, Amsterdam. "Heroische Sinnbilder"
Bonner Kunstverein, Bonn. "Anselm Kiefer"*
(Cat.: texts by Dorothea von Stetten and Evelyn Weiss)
Galerie Michael Werner, Cologne. "Ritt an die Weichsel"

1974
Galerie Felix Handschin, Basle. "Alarichs Grab"
Galerie Michael Werner, Cologne. "Malerei der verbrannten Erde"

1973
Galerie im Goethe-Institut, Amsterdam. "Der Nibelungen Leid"
Galerie Michael Werner, Cologne. "Notung"

1969
Galerie am Kaiserplatz, Karlsruhe. "Anselm Kiefer"

Group Exhibitions

2000
The National Gallery, London. »Encounters. New Art From Old«*

1999
Stedelijk Museum voor Actuele Kunst, Ghent

1997
Guggenheim Museum Bilbao
La Biennale di Venezia, 47. Esposizione internazionale d'arte. "Anselm Kiefer: Himmel-Erde"*

1996
Museum of Contemporary Art, Chicago. "Negotiating Rapture. The Power of Art to Transform Lives"*

1995
Ludwig Forum für Internationale Kunst, Aachen. "Deutsche Kunst nach 1945"*
Museum für Neue Kunst, Freiburg. "Tag um Tag = 30 Jahre – Ehemalige der Klasse Peter Dreher"*

1994
Gallery of the Royal Scottish Academy, Edinburgh, Hayward Gallery, London, Haus der Kunst, Munich. "The Romantic Spirit in German Art: 1790–1990"*
Galerie Thaddeus Ropac, Paris. "Aspekte deutscher Kunst: 1964–1994. Eine Ausstellung der Salzburger Festspiele und der Galerie Thaddeus Ropac, Salzburg/Paris"*

1992
Walker Art Center, Minneapolis, Dallas Museum of Art, Modern Art Museum of Fort Worth, Guggenheim Museum, New York. "Photography in Contemporary German Art: 1960 to the Present"*
Kunsthal Rotterdam. "Warhol – Kiefer – Clemente: Werken op papier/Works on Paper"*

1991
Kunsthalle der Hypo-Kulturstiftung, Munich, Von der Heydt-Museum, Wuppertal. "Denk-Bilder. Kunst der Gegenwart: 1960–1990"*

1990
Stedelijk Museum, Amsterdam. "1990 – Energieen"*
Israel Museum, Jerusalem. "Life Size"*

1989
Künstlerhaus Bethanien, Berlin. "Ressource Kunst – Die Elemente neu gesehen"*
Centre Georges Pompidou et Grand Halle de La Villette, Paris. "Magiciens de la terre"*
Germanisches Nationalmuseum, Nürnberg. "Freiheit, Gleichheit, Brüderlichkeit – 200 Jahre Französische Revolution in Deutschland"*
The National Museum of Art, Osaka. "Drawing as Itself"*

1988
Museum of Art, Toledo (Ohio), Solomon Guggenheim Museum, New York, Kunstmuseum Düsseldorf, Schirn Kunsthalle Frankfurt, Frankfurt/M. "Neue Figuration. Deutsche Malerei 1960–1988"*
Carnegie Museum of Art, Pittsburgh. "1988 Carnegie International"*
Art Gallery of New South Wales, Sydney. "The Seventh Biennale of Sydney"*

1987
Museum Fridericianum, Kassel. "documenta 8"*
Los Angeles Museum of Contemporary Art. "Avant-Garde in the Eighties"*
ARC – Musée d'Art Moderne de la Ville de Paris. "L'Epoque, la mode, la morale, la passion: Aspects de l'art d'aujourd'hui, 1977–1987"*
Biennale de São Paulo
Staatsgalerie Stuttgart. "Deutsche Kunst im 20. Jahrhundert: Malerei und Plastik 1905–1985"*

1986
Kunsthalle Basel. "Joseph Beuys, Enzo Cucchi, Anselm Kiefer, Jannis Kounellis"*
Neue Galerie im Alten Museum, Berlin (Ost), Staatliche Kunstsammlungen Dresden. "Positionen. Malerei aus der Bundesrepublik Deutschland"*
Museum Ludwig, Cologne. "Europa – Amerika. Die Geschichte einer künstlerischen Faszination"*
Los Angeles Museum of Contemporary Art. "Individuals. A Selected History of Contemporary Art 1945–1986"*
The Saatchi Collection, London. "Anselm Kiefer/Richard Serra"*

1985
Neue Nationalgalerie Berlin, Staatliche Museen – Preußischer Kulturbesitz. "Kunst in der Bundesrepublik Deutschland"*
Royal Academy of Arts, London. "German Art in the 20th Century: Painting and Sculpture 1905–1985"*
Carnegie Museum of Art, Pittsburgh. "1985 Carnegie International"*

1984
Exhibition centre, pavilion 13, Düsseldorf. "von hier aus. Zwei Monate neue deutsche Kunst in Düsseldorf"*
Scottish National Gallery of Modern Art, Edinburgh. "Creation, Modern Art and Nature"*
Fondació Caixa de Pensions, Barcelona et al. "Origen y Vision. Nueva pintura alemana/Ursprung und Vision. Neue deutsche Malerei"*
Museum of Modern Art, New York. "International Survey of Recent Painting"*
Art Gallery of New South Wales, Sydney. "The 5th Biennale of Sydney. Private Symbol, Social Metaphor"*

1983

Louisiana Museum of Modern Art, Humlebæk. "Tysk Maleri Omkring 1980: Den Nye Ekspressionisme"*
Saint Louis Art Museum et al. "Expressions. New Art from Germany, Georg Baselitz, Jörg Immendorff, Anselm Kiefer, Markus Lüpertz, A. R. Penck"*
Kunsthaus Zürich et al. "Der Hang zum Gesamtkunstwerk"*

1982

Stedelijk Museum, Amsterdam. "'60, '80: Attitudes/Concepts/Images"*
Martin-Gropius-Bau, Berlin. "Zeitgeist"*
Städtische Kunsthalle, Düsseldorf. "Bilder sind nicht verboten"*
Museum Fridericianum, Kassel. "documenta 7"*

1981

Museen der Stadt Köln, Exhibition centre. "Westkunst. Zeitgenössische Kunst seit 1939"*
Royal Academy of Arts, London. "A New Spirit in Painting"*
ARC – Musée d'Art Moderne de la Ville de Paris. "Art allemagne aujourd'hui"*

1980

Neue Galerie – Sammlung Ludwig, Aachen. "Les nouveaux Fauves/Die neuen Wilden"*
Frankfurter Kunstverein, Frankfurt/M. "Zwischen Krieg und Frieden. Gegenständliche und realistische Tendenzen in der Kunst nach '45"*

1977

Louisiana Museum of Modern Art, Humlebæk. "Pejling af tysk kunst"
Museum Fridericianum, Kassel. "documenta 6"*

1976

Frankfurter Kunstverein, Frankfurt/M. "Beuys und seine Schüler"*

1973

Staatliche Kunsthalle Baden-Baden. "14 mal 14"*

1969

Kunstverein, Hanover. "17. Ausstellung des Deutschen Künstlerbunds"*
Karl-Arnold-Bildungsstätte, Bad Godesberg. Staatliche Akademie der Bildenden Künste, Karlsruhe

Selected Bibliography

Monographs, Essays, Interviews

2001

Arasse, Daniel, *Anselm Kiefer. Die große Monographie,* trans. by Reinold Werner, Munich 2001 (French edition: Paris 2001)

Lloyd, Jill, "Interview Anselm Kiefer. Lad tusind blomster blomstre", *Louisiana Magasin,* vol. 2, 2001, pp. 2–6

McEvilley, Thomas, "Let a Thousand Flowers Bloom", in *Anselm Kiefer. Paintings 1998–2000,* exh. cat. Louisiana Museum of Modern Art, Humlebæk 2001, pp. 6–22

Schwerfel, Heinz Peter, "Anselm Kiefer, 'Ich wollte noch einmal neu anfangen'. Ein Interview mit Anselm Kiefer", *art* 7, 2001, pp. 14–29

Wagner, Monika, "Kiefers Versandungen und Jetelovás Sandkatastrophen", in id., *Das Material der Kunst. Eine andere Geschichte der Moderne,* Munich 2001, pp. 127–133

2000

Alvarez, José, "Anselm Kiefer à la chapelle de la Salpêtrière", *Connaissance des Arts* 575, Summer 2000, pp. 30–31 (Review of exh. Chapelle de la Salpêtrière, Paris, 2000)

Auping, Michael, "Anselm Kiefer. Satanic Reverses", *ARTnews* 1, vol. 99, January 2000, pp. 106–108

Dickel, Hans, "Der Fall Kiefer", *Kritische Berichte,* vol. 28, 2000, pp. 87–92 (Book review of Biro 1998 and Saltzman 1999)

Fenne, Christina, *Anselm Kiefer. Historienmalerei nach Auschwitz,* Ph. D.-thesis., Univ. Witten-Herdecke 2000 (microfiche edition)

Kiefer, Anselm, *ich halte alle Indien in meiner Hand,* Munich 2000

Rampley, Matthew, "In Search of Cultural History. Anselm Kiefer and the Ambivalence of Modernism", *The Oxford Art Journal* 1, vol. 23, 2000, pp. 73–96

Strasser, Catherine, "Anselm Kiefer", in *Chevirat Ha-Kelim. Le bris des vases. Anselm Kiefer,* exh. cat. Chapelle de la Salpêtrière, Festival d'Automne à Paris 2000, pp. 15–53

1999

Alvarez, José, "Anselm Kiefer. Un peuple de statues dont le silence épouvante les maîtres", *Connaissance des Arts* 566, November 1999, pp. 90–93 (Review of exh. Galerie Yvon Lambert, Paris, 1999)

Cordulack, Shelley, "Anselm Kiefer. Art, Work and Vocation in the Third Reich", *Bruckmanns Pantheon,* vol. 57, 1999, pp. 169–177

Dietrich, Dorothea, "Anselm Kiefer. Works on Paper. The Metropolitan Museum of Art, New York", *Art on Paper* 4, vol. 3, March–April 1999, pp. 57–58 (Review of exh. The Metropolitan Museum of Art, New York, 1999)

Eccher, Danilo, "Anselm Kiefer. Eine undurchsichtige Seele", in *Anselm Kiefer. Stelle cadenti,* trans. by Lydia Kessel, exh. cat. Galleria d'Arte Moderna di Bologna, Turin/London 1999, pp. 105–120

Kiefer, Anselm, *über euren Städten wird Gras wachsen,* Munich 1999

Kramer, Hilton, "Anselm Kiefer. Delusions of Grandeur", *Art & Antiques* 3, March 1999, pp. 136–137 (Review of exh. The Metropolitan Museum of Art, New York, 1999)

Saltzman, Lisa, *Anselm Kiefer and Art after Auschwitz,* New York 1999

Schjeldahl, Peter, "Springtime for Kiefer", *The New Yorker* 42, vol. 74, 18 January 1999, pp. 83–84 (Review of exh. The Metropolitan Museum of Art, New York, 1999)

Schütz, Sabine, *Anselm Kiefer – Geschichte als Material: Arbeiten 1969–1983,* Cologne 1999

Zervigón, Andrés Mario, "Kiefer's Paradox", *art journal* 3, vol. 58, Spring 1999, pp. 103–105 (Review of Biro 1998, Saltzman 1999, The Metropolitan Museum of Art, New York, 1999)

1998

Alvarez, José, "Anselm Kiefer. Un art de la complétude", *Connaissance des Arts* 551, June 1998, pp. 78–85 (Review of exh. Museo Nacional Centro de Arte Reina Sofía, Madrid, 1998)

Bastian, Heiner (ed.), *Anselm Kiefer. Dein und mein Alter und das Alter der Welt/Your Age and Mine and the Age of the World,* exh. cat. Gagosian Gallery, New York, Munich 1998

Biro, Matthew, *Anselm Kiefer and the Philosophy of Martin Heidegger,* New York 1998

Colard, Jean-Max, "Kiefer par-delà le chaos", *Beaux Arts Magazine* 170, July 1998, pp. 38–43 (Review of exh. Museo Nacional Centro de Arte Reina Sofía, Madrid, 1998)

Fahrbach-Dreher, Ute, "Höpfingen. Ziegelei wird Gesamtkunstwerk", *Denkmalpflege in Baden-Württemberg* 2, vol. 27, April–June 1998, pp. 84–85

Flórez, Fernando Castro, "Exorcisms. The Untimely Painting of Anselm Kiefer", in *El viento, el tiempo, el silencio,* exh. cat. Museo Nacional Centro de Arte Reina Sofía (Palacio de Velázquez), Madrid 1998, pp. 174–189

Frankel, David, "Anselm Kiefer. Gagosian Gallery", *Artforum* 9, vol. 36, May 1998, p. 144

Gockel, Cornelia, *Zeige deine Wunde. Faschismusrezeption in der deutschen Gegenwartskunst,* Ph. D.-thesis, Munich 1998

Kiefer, Anselm, *20 Jahre Einsamkeit, 1991,* Paris 1998

Rose, Barbara, "Kiefer's Cosmos", *Art in America* 12, vol. 86, December 1998, pp. 70–73

1997

Attias, Laurie, "Anselm Kiefer's Identity Crisis", *ARTnews* 6, vol. 96, June 1997, pp. 108–111

Hyman, James, "Anselm Kiefer as Printmaker – I. A Catalogue (1973–1993)", *Print Quarterly* 1, vol. 14, March 1997, pp. 42–67

Hyman, James, "Journey to the Centre of the Earth", *Tate* 11, Spring 1997, pp. 46–51

1996

Arasse, Daniel, "De Mémoire de Tableaux", in *Anselm Kiefer. Cette obscure clarté qui tombe des étoiles,* exh. cat. Galerie Yvon Lambert, Paris 1996, n. p.

Comment, Bernard, "Interview d'Anselm Kiefer. Cette obscure clarté qui tombe des étoiles – 'This dark light that falls from the stars...'", *ARTpress* 216, September 1996, pp. 19–27

Hofmann, Michael, "Kiefer in French?", *Modern Painters* 4, vol. 9, Winter 1996, pp. 32–34

López-Pedraza, Rafael, *Anselm Kiefer. The Psychology of "After the Catastophe",* New York 1996

Nash, Douglas, *The Politics of Space. Architecture, Painting and the Theater in Postmodern Germany,* Frankfurt/M./Bern 1996

Schuster, Peter-Klaus, "Anselm Kiefer", in Heiner Bastian (ed.), *Sammlung Marx,* exh. cat. Hamburger Bahnhof, Museum für Gegenwart, Berlin 1996, vol. I, pp. 123–127

1995

Metken, Günter, "Theater der Erinnerung", in id., *Laut-Malereien. Grenzgänge zwischen Kunst und Musik,* Frankfurt/M. 1995, pp. 57–62

1994

Borreil, Jean (ed.), *Ateliers I. Esthétique de l'écart,* Paris 1994

Bucher-Vogler, Christine, *Von der Lichtlandschaft zur Stadtverwaldung. Natur- und Landschaftsdarstellung in der westdeutschen Kunst nach 1945,* Frankfurt/M./Bern/New York 1994

Meier, Cordula, "Das Archiv der Malerei. Kunst und Gedächtnis am Beispiel Anselm Kiefers", in Anne von der Heiden (ed.), *Ästhetik und Verantwortung. Festschrift für Matthias Kohn,* Essen 1994, pp. 155–170

1993

Buck, Theo, *Bildersprache. Celan-Motive bei László Lakner und Anselm Kiefer,* Aachen 1993

Koerner, Lisbet, "Nazi Medievalist Architecture and the Politics of Memory", *Studies of Medievalism,* vol. 5, 1993, pp. 48–75

Kuspit, Donald B., "Anselm Kiefer's Will to Power", in Donald B. Kuspit, *Signs of Psyche in Modern and Postmodern Art,* Cambridge 1993, pp. 228–236

Rosenblum, Robert, "A Postscript. Some Recent Neo-Romantic Mutations", *art journal* 2, vol. 52, Summer 1993, pp. 74–84

1992

Belting, Hans, *Die Deutschen und ihre Kunst. Ein schwieriges Erbe,* Munich 1992, p. 58

Esser, Werner, *Anselm Kiefer. Glaube, Hoffnung, Liebe,* Stuttgart 1992

Flam, Jack, "The Alchemist", *The New York Review of Books* 4, vol. 39, 13 February 1992, pp. 31–36

Huyssen, Andreas, "Kiefer in Berlin", *October* 62, Autumn 1992, pp. 84–101 (Review of exh. Nationalgalerie Berlin, 1991)

Marx, Katja, "Plötzlich ist das Geld wie ein Geschwür. Den Kunstpark 'Zweistromland' wird es nicht geben – Anselm Kiefer scheitert mit seiner großen Idee", *Die Zeit*, 21 February 1992
Meier, Cordula, *Anselm Kiefer. Die Rückkehr des Mythos in der Kunst,* Ph. D.-thesis, Essen 1992
Rhodes, Colin, "Books of Anselm Kiefer, 1969–1990", *Burlington Magazine* 1073, vol. 134, August 1992, p. 535
(Review of exh. Kunsthalle Tübingen et al., 1990–1991)

1991
Benjamin, Andrew, "Kiefer's Approaches", in Andrew Benjamin and Peter Osborne (eds.), *Thinking Art. Beyond Traditional Aesthetics,* (ICA documents 10), London 1991, pp. 95–109
Faust, Wolfgang Max, "Die bleiernen Flügel des Anselm Kiefer", *art* 5, 1991, pp. 48–50
(Review of exh. Nationalgalerie Berlin, 1991)
Kimpel, Harald, and Johanna Werckmeister, "Leidmotive. Möglichkeiten der künstlerischen Nibelungen-Rezeption seit 1945", in Joachim Heinzle and Anneliese Waldschmidt (eds.), *Die Nibelungen,* Frankfurt/M. 1991, pp. 284–306
LeVitté-Harten, Doreet, "Bruch der Gefäße", in *Anselm Kiefer*, exh. cat. Nationalgalerie Berlin 1991, pp. 20–28
Schneider, Angela, "*Resurrexit* oder eine Tour d'Horizon zu den neueren Werken", in *Anselm Kiefer,* exh. cat. Nationalgalerie Berlin 1991, pp. 115–121

1990
Cone, Michèle, "Suspicious 'unheimlich' and Ambivalence in the Appropriation Strategy of Anselm Kiefer", *art criticism* 2, vol. 6, 1990, pp. 12–20
Ermen, Reinhard, "Der Engel der Geschichte", *Kunstforum International,* vol. 106, pp. 325–326
(Review of exh. Galerie Paul Maenz, Cologne, 1989)
Gilmour, John C., *Fire on the Earth. Anselm Kiefer & the Postmodern World,* Philadelphia 1990
Hecht, Axel, and Alfred Nemeczek, "Malen als heroische Tat. Bei Anselm Kiefer im Atelier", *art* 1, 1990, pp. 30–48
Kämmerlin, Christian, and Peter Pursche, "'Nachts fahre ich mit dem Fahrrad von Bild zu Bild'. Ein Werkstattgespräch mit Anselm Kiefer über seine Arbeit und seine Weltsicht", *Süddeutsche Zeitung Magazin* 46, 16 November 1990, pp. 24–30
Kiefer, Anselm, *Über Räume und Völker. Ein Gespräch mit Anselm Kiefer,* epilogue by Klaus Gallwitz, Frankfurt/M. 1990

1989
Berrio, Antonio García, "Ambiguity as a Mask of Memory. Anselm Kiefer", *Revista de Occidente* 100, September 1989, pp. 126–128
Fuchs, Rudi H., "Chicago Lecture", *tema celeste* 19, January–March 1989, pp. 49–59
Haxthausen, Charles Werner, "Kiefer in America. Reflections on a Retrospective", *Kunstchronik,* no. 42, January 1989, pp. 1–16
(Review of exh. The Art Institute of Chicago et al., 1987–89)

Huyssen, Andreas, "Anselm Kiefer. The Terror of History. The Temptation of Myth", *October* 48, Spring 1989, pp. 25–45
Kiefer, Anselm, *Zweistromland,* with an essay by Armin Zweite, Cologne 1989
Rubin, William, "A Dissent on Kiefer", *New Criterion,* vol. 7, March 1989, pp. 84–86

1988
Dietrich, Dorothea, "Decoding Kiefer", *Print Collector's Newsletter* 4, vol. 19, September–October 1988, pp. 156–158
Kramer, Hilton, "The Anselm Kiefer Retrospective", *Art in America,* March 1988, pp. 116–127
(Review of exh. The Art Institute of Chicago et al., 1987–1989)
Schjeldahl, Peter, "Our Kiefer", *Art in America* 3, vol. 76, March 1988, pp. 116–127
(Review of exh. The Art Institute of Chicago et al., 1987–1989)
Stebbins, Theodore E., jr., and Susan Cragg Ricci, *A Book by Anselm Kiefer,* foreword by Jürgen Harten, exh. cat. Museum of Fine Arts, Boston, New York 1988, p. 22

1986
Brock, Bazon, "Besetzung und Bilderkrieg als affirmative Strategien. Anselm Kiefer", in Bazon Brock, *Ästhetik gegen erzwungene Unmittelbarkeit. Die Gottsucherbande,* Cologne 1986, pp. 293–298
Burckhardt, Jacqueline (ed.), *Ein Gespräch – Una Discussione. Joseph Beuys, Enzo Cucchi, Anselm Kiefer, Jannis Kounellis,* Zurich 1986
Grasskamp, Walter, "Anselm Kiefer. Der Dachboden", in id., *Der vergeßliche Engel. Künstlerporträts für Fortgeschrittene,* Munich 1986, pp. 7–22

1985
Kneubühler, Theo, *Malerei als Wirklichkeit. Baselitz, Höckelmann, Kiefer, Kirkeby, Lüpertz, Penck,* ed. and introd. by Johannes Gachnang, Berlin 1985
Landau, Suzanne, "Landscape as Metaphor. Anselm Kiefer's *Aaron*", *Israel Museum Journal* IV, 1985, pp. 63–66
Ottmann, Klaus, "The Solid and the Fluid. Bartlett, Laib, Kiefer", *Flash Art* 123, Summer 1985, pp. 48–49
Schmidt, Katharina, "*to the supreme being.* Ein Gemälde von Anselm Kiefer", *Artefactum* 8, vol. 2, April–May 1985, pp. 8–15

1984
Bell, Jane, "What is German about the New German Art?", *ARTnews* 3, vol. 83, March 1984, pp. 96–101
(Review of exh. Saint Louis Art Museum et al., 1983)
Caldwell, John, "Anselm Kiefer's *Dem unbekannten Maler (To the Unknown Painter)*", *Carnegie Magazine,* vol. 57, January–February 1984, pp. 6–8
Hecht, Axel, "Anselm Kiefer. Macht der Mythen", *art* 3, 1984, pp. 20–33
Hoppe-Sailer, Richard, "Anselm Kiefer. Peinture et histoire", *Artistes,* nos 22/23, 1984
Schjeldahl, Peter, "Anselm Kiefer", *Art of our Time. The Saatchi Collection,* London/New York 1984, vol. 3, pp. 15–17

1983
Schmidt, Katharina, "Anmerkungen zum Werk von Anselm Kiefer", in *Anselm Kiefer. Bücher und Gouachen,* exh. cat. Hans-Thoma-Museum, Bernau/Black Forest 1983, n. p.
Schwartz, Sanford, "Anselm Kiefer, Joseph Beuys, and the Ghosts of the Fatherland", *New Criterion* 7, no. 1, March 1983, pp. 1–9
Schwarz, Michael, "Anselm Kiefer. *Des Malers Atelier,* 1980", in Rolf H. Kraus, Manfred Schmalriede, Michael Schwarz (eds.), *Kunst mit Photographie. Die Sammlung Dr. Rolf H. Krauss,* exh. cat. Nationalgalerie Berlin et al., Berlin 1983, pp. 96–98

1982
Faust, Wolfgang Max, and Gerd de Vries, "Anselm Kiefer", in Wolfgang Max Faust and Gerd de Vries, *Hunger nach Bildern,* Cologne 1982, pp. 73–80
Gachnang, Johannes, "New German Painting", *Flash Art* 106, February–March 1982, pp. 33–37
Kuspit, Donald B., "Acts of Aggression. German Art Today. Part I", *Art in America* 8, vol. 70, September 1982, pp. 140–151

1981
Bann, Stephen, "A New Spirit in Painting", *Connaissance des Arts* 356, October 1981, pp. 98–105
(Review of exh. Royal Academy of Arts, London, 1981)
Buchloh, Benjamin H. D., "Figures of Authority. Ciphers of Regression. Notes on the Return of Representation in European Painting", *October* 16, Spring 1981, pp. 39–68

1980
Brock, Bazon, "Avantgarde und Mythos. Möglichst taktvolle Kulturgesten vor Venedigheimkehrern", *Kunstforum International,* vol. 40, 1980, pp. 86–103
Fuchs, Rudi H., "Kiefer malt", in Klaus Gallwitz (ed.), *Anselm Kiefer. Verbrennen, verholzen, versenken, versanden,* exh. cat. Biennale Venedig 1980, Deutscher Pavillon, Frankfurt/M. 1980
Gercken, Günther, "Holz-(schnitt)-wege", in *Anselm Kiefer,* exh. cat. Groninger Museum, Groningen 1980

1979
Gachnang, Johannes, "Anselm Kiefer. Vom Verhältnis der Schweizer zur deutschen Kultur und von einer 'neuen Malerei'", *Kunst Nachrichten,* no. 1, January 1979, pp. 57–62

1978
Müller, Hans-Joachim, "Anselm Kiefer. Bilder und Bücher", *Das Kunstwerk* 6, vol. 31, December 1978, pp. 62–63
(Review of exh. Kunsthalle Bern, 1978)

1975
Kiefer, Anselm, "Besetzungen 1969", *Interfunktionen* (Zeitschrift für neue Arbeiten und Vorstellungen) 12, 1975, pp. 133–144

Compiled by Viola Weigel

Authors

Markus Brüderlin, born in 1958 in Basel; studied art history, the teaching of art, philosophy and German in Vienna, taking his doctorate on 20th-century abstract art. He is a writer and curator who founded the Kunstraum Wien in 1994. Since the autumn of 1996 he has been Chief Curator of the Fondation Beyeler in Riehen/Basel, Switzerland.

Thomas Flechtner, born in 1961 in Winterthur/ Switzerland; lives and works in La Sagne/Canton of Neuchâtel. From 1983–87 he studied photography in Vevey. He subsequently received a number of awards and grants, including a year working in London that was funded by the Landis & Gyr Cultural Foundation in Zug. He has held exhibitions in Switzerland and abroad, in particular at the Galerie Linder in Basel and the Galerie Renn in Paris. *SNOW,* a book of his photographs, is being published by the Lars Müller Verlag in 2001.

Christoph Ransmayr, born in 1954 in Wels/ Upper Austria; studied philosophy at the University of Vienna from 1972–78. He currently lives in West Cork, Ireland. He first started working in the literary field in 1979 when he became the cultural editor for the Viennese monthly *Extrablatt* and a contributor to the magazines *TransAtlantik, Merian* and *Geo.* His narrative work in rhythmic prose *Strahlender Untergang. Ein Entwässerungsprojekt oder die Entdeckung des Wesentlichen* marked the beginning of his career as an independent author in 1982. Other works he has written are: *Die Schrecken des Eises und der Finsternis* (novel, 1984); *Die letzte Welt* (novel, 1988); *Morbus Kitahara* (novel, 1995); *Der Weg nach Surabaya* (reportages and prose pieces, 1997); *Die Unsichtbare* (novel, 2001). A stage version of *Die Unsichtbare* was directed by Claus Peymann at the Salzburg Festival in 2001.

Mark Rosenthal, born 1945 in Philadelphia/ U.S.A.; took his doctorate degree at the University of Iowa on Paul Klee in 1979. He was curator at the Solomon R. Guggenheim Museum, New York, from 1989 until 1993 and 1996 until 2000 at the National Gallery of Art, Washington, D.C. In 1987 he organized an exhibition about Anselm Kiefer for the Philadelphia Museum of Art. His writings and exhibitions have been devoted to Jasper Johns, Ellsworth Kelly, Pablo Picasso, Paul Klee, and Juan Gris, as well as to Abstraction in the 20th-century.

Katharina Schmidt, born in St. Goar/Rhine, Germany; studied theatre history and art history in Munich and Vienna, taking her doctorate in Vienna in 1968. From 1972–81 she was the curator of the Kunsthalle in Düsseldorf; from 1981–85 she was the head of the Staatliche Kunsthalle in Baden-Baden; from 1985–92 she was the director of the Kunstmuseum Bonn (construction of the museum) and from 1992–2001 she was the director of the Öffentliche Kunstsammlung Basel (Kunstmuseum Basel and the Museum für Gegenwartskunst). She has organized a large number of international exhibitions and has written authoritative publications on 19th and 20th-century art.

Photographic Credits

Exhibition
Markus Brüderlin

Research Assistants
Tanja Narr
Viola Weigel

Project Director
Markus Brüderlin

Realization
Verena Formanek (Overall Coordination)
Nicole Rüegsegger (Registrar)
Ben Ludwig (Head of Technical Installation)
Ahmed Habbech
Dieter von Arx

Conservation
Markus Gross
Friederike Steckling

Insurance
Alex C. Pfenniger

Public Relations
Bettina Mette

Corporate Communication
Marina Targa

Fondation Beyeler
Baselstrasse 101
4125 Riehen/Basel
Switzerland
Tel. +41 (0) 61 645 97 00
Fax +41 (0) 61 645 97 19
www.beyeler.com
fondation@beyeler.com

This volume is published to accompany the exhibition
"Anselm Kiefer. the Seven Heavenly Palaces 1973–2001"
at the Fondation Beyeler, Riehen/Basel,
28 October 2001 until 17 February 2002.

Edited by
Fondation Beyeler

Concept
Markus Brüderlin
Urs Albrecht

Editing
Delia Ciuha (Editing Director)
Astrid Bextermöller
Viola Weigel

Translation
David Britt (Texts by Markus Brüderlin and Katharina Schmidt)
Isabel Feder (Acknowledgements)
Ishbel Flett (Hekhalot text)
John E. Woods (Essay by Christoph Ransmayr)

Graphic Design
Urs Albrecht

Production
Christine Müller

Reproduction
C+S Repro, Filderstadt

Printed by
Dr. Cantz'sche Druckerei, Ostfildern-Ruit

Published by
Hatje Cantz Publishers
Senefelderstraße 12
73760 Ostfildern-Ruit
Germany
Tel. +49 (0) 711 4 40 50
Fax +49 (0) 711 4 40 52 20
http://www.hatjecantz.de

DISTRIBUTION IN THE US
D.A.P., Distributed Art Publishers, Inc.
155 Avenue of the Americas, Second Floor
New York, N.Y. 10013-1507
USA
Tel. +1/2 12/6 27 19 99
Fax +1/2 12/6 27 94 84

ISBN 3-905632-17-9 (Museum edition)
ISBN 3-7757-1125-2 (Trade edition)

Printed in Germany

Die Deutsche Bibliothek - CIP Cataloguing-in-Publication-Data

Anselm Kiefer, the seven heavenly palaces 1973 - 2001 : [to accompany the Exhibition "Anselm Kiefer. The Seven Heavenly Palaces 1973 - 2001" at the Fondation Beyeler Riehen/Basel, 28 October 2001 until 17 February 2002] / with an essay by Christoph Ransmayr and contributions by Markus Brüderlin ... [Ed.: Delia Ciuha ... Transl.: David Britt ...]. - Ostfildern-Ruit : Hatje Cantz, 2001
 Dt. Ausg. u.d.T.: Anselm Kiefer, die sieben HimmelsPaläste 1973 - 2001
 ISBN 3-7757-1125-2

Cover Illustrations
Front:
Anselm Kiefer, *Your Age and My Age and the Age of the World*, 1997 (cat. 15, pp. 68–69)
Back:
Anselm Kiefer, *Resurrexit*, 1973 (cat. 4, p. 41)
Inside, page 2:
Renzo Piano, *Fondation Beyeler*, 1997